Plantation
Between the Waters

Plantation Between the Waters

A Brief History of Hobcaw Barony

Lee G. Brockington
The Belle W. Baruch Foundation
Foreword by Suzanne Linder Hurley

Charleston London

History
PRESS

Published by The History Press
18 Percy Street
Charleston, SC 29403
866.223.5778
www.historypress.net

Front cover image: Clambank Landing on Goat Island, seen here ca. 1907, featured both a mid-nineteenth-century and a recently built structure, both used as hunt cabins.
Back cover image: Belle Baruch, ca. 1936, at home on Bellefield Plantation near Georgetown, South Carolina, after a turkey shoot.

All photographs are a part of the Belle W. Baruch Foundation archives unless otherwise noted.

First published 2006

Manufactured in the United Kingdom

ISBN 1.59629-106-0

Library of Congress Cataloging-in-Publication Data

Brockington, Lee.
 Plantation between the waters : a brief history of Hobcaw Barony
 / Lee Brockington ; foreword by Suzanne Linder Hurley.
 p. cm.
 Includes bibliographical references and index.
 ISBN 1-59629-106-0 (alk. paper)
 1. Hobcaw Barony (S.C.)--History. 2. Georgetown County (S.C.)
--History, Local. 3. Plantations--South Carolina--Georgetown County
--History. 4. Forest reserves--South Carolina--Georgetown County.
 I. Title.
 F277.G35B76 2006
 975.7'89--dc22
 2005036376

Contents

Foreword

The history of Hobcaw Barony in many ways reflects that of Lowcountry South Carolina. Hobcaw's location, between the Waccamaw River, with its estuary Winyah Bay, and the Atlantic Ocean, has made it valuable and strategic land from earliest times to the present day. Its 17,500 acres—or more than twenty-seven square miles—include seashore, both freshwater and saltwater marsh, river swamp, maritime forest and timber land. The location was significant to Native Americans, who named the land Hobcaw and visited the peninsula in numbers great enough to form a path that European settlers later transformed into a road called the King's Highway.

The Lords Proprietors of Carolina set up the first English government under the Fundamental Constitutions, a document strongly influenced by political philosopher John Locke. Although the document was never officially ratified by the colonists, some provisions became de facto law and provided for a titled nobility based on ownership of twelve-thousand-acre baronies. One of the Lords Proprietors, Sir John Carteret, later Earl of Granville, claimed Hobcaw Barony in 1718. He sold the barony in 1730, when the British King bought out the Proprietors and took over the colony, and the barony land became available for sale to settlers who soon realized the potential for producing naval stores and growing rice. Because of the abundance of free land, the titles of nobility based on landholding gradually became obsolete. Nevertheless, the planters on the Waccamaw Neck were sometimes called "rice barons" because of the wealth and influence they enjoyed. They played an important part in South Carolina history both economically and politically.

After the Civil War, as rice production became progressively less profitable, wealthy Northerners began purchasing former rice plantations for use as vacation homes and hunting preserves. Bernard Baruch, financier and advisor to presidents, purchased a number of plantations on Waccamaw Neck between 1905 and 1907. Baruch wanted to reassemble the original Hobcaw Barony. Although he was unable to match exactly the boundaries of the Proprietary Era, he eventually owned much more than twelve thousand acres.

From the turn of the twentieth century, the story of Hobcaw is principally about the Baruch family, a true American success story. Bernard Baruch's father was a Jewish

immigrant who became a successful physician in South Carolina and then in New York City. Family photographs reveal a close-knit family of three generations who gathered at Hobcaw for holidays. Fishing, boating and hunting provided plenty of entertainment for the family as well as for illustrious guests.

Of his three children, Bernard Baruch's daughter Belle was most interested in owning Hobcaw. After purchasing it from her father, she made it her home and became a leader in preserving the South Carolina coastline. She set up a foundation to own and operate Hobcaw Barony in perpetuity as a research facility and outdoor laboratory. Others followed her example, and today some sixty miles of seashore, including Hobcaw, are protected from development and available in some way to the public.

Lee Brockington, senior interpreter at Hobcaw, has written this history as one who truly loves the land and knows its story "by heart." She has condensed centuries of history into a lively and readable narrative. The archival photographs give an intimate glimpse into the private lives of an important American family and their guests, some of whom were world famous. In addition, fine photographs by Jane Allen Nodine provide glimpses of the unspoiled landscape. In many ways, Hobcaw is like a unique time capsule that has preserved the land largely undisturbed since it was developed by eighteenth- and nineteenth-century rice planters. Historic buildings, from slave houses and a plantation church to Baruch's great mansion, enable visitors to step back in time.

The book is valuable in placing Hobcaw within the context of South Carolina and national history. Perhaps it will encourage more motorists who pass by on Highway 17 to stop and enjoy a section of coastline that has not been altered by modern development; or perhaps it will present ideas that will stimulate biologists, foresters or historians to create new proposals for research leading to important solutions to problems of ecology. Although only a privileged few could visit the original Hobcaw Barony, today this underappreciated treasure is open for public tours.

Belle Baruch, who wanted to preserve the land and to provide a place for scholars to study, might echo William Wordsworth:

Come forth into the light of things,
Let Nature be your teacher.

—*"The Tables Turned"*

Suzanne Linder Hurley
Davidson, North Carolina

Acknowledgements

I am indebted to many people who shared not only their information on Hobcaw Barony, but also their love of the plantation. Since my first visit in November 1983 in search of information on feral swine, I was entranced with the layers of cultural and natural history. I am grateful to Wendy Allen, who created a position for me in early 1984 and who introduced me to Miss Ella Severin, the trustee and close friend of Belle Baruch. Miss Severin's fifty-year residency guided trustees, staff and researchers in Belle's vision and plan for the property. Rhett Talbert and Dr. Richard Porcher began the unraveling of the complicated history of the land for me, and Bruce Lampright led me into the complex world of Hobcaw's ecology. Dr. Charles Joyner, who influenced me as an undeclared major in college, produced his study of the slave community of All Saints Parish as if for me, for his *Down by the Riverside* features research and observations on Friendfield Plantation's slave village. Archaeologist Jim Michie encouraged me to be silent and to let the land answer my questions, while Dr. Paul Brockington Jr. identified countless artifacts for me. Emory Campbell, director emeritus of the Penn Center on St. Helena Island, South Carolina, traveled some of the one hundred miles of Hobcaw's dirt roads. Lamenting the changes in his native Hilton Head Island, he quietly reminded me how precious undeveloped land truly is.

I also wish to thank museum professionals Janet Bruce and Jim Vaughan, Bettie Kerr, Andy Masich, Doug Alves, Dave Donath, Clarence Fox, Horace Harmon, Rodger Stroup, Robin Salmon, Judy Kennedy, Selden Hill and Rick Shackelford. Dr. Walter Edgar, Dr. Dale Rosengarten, Dr. Selden Smith and Suzanne Linder Hurley have shared their scholarly expertise with me. Plantation managers Neal Cox, Gurdon Tarbox, Kenny Williams, Bob Joyner and the South Carolina Department of Natural Resources staff members Mark Bara, Mark Spinks, Dean Cain and Phillip Wilkinson stood braced for questioning at each encounter. Georgetown County Library staff members Dwight McInvaill, Trudy Bazemore and Sheila Sullivan have been greatly appreciated supporters of our research and programs at Hobcaw.

Locals who were willing to share their remembrances include Genevieve "Sister" Peterkin, Frank and Faye Marlow, Boyd and Lucienne Marlow, Alberta Quattlebaum, Patricia Doyle, Ralph Ford, Tootsie Watkins, George Young, Willie Dereef, Richard Brown, Herbert Wigfall and George Brown.

Hobcaw's former residents shared great insight into the past. I thank Prince and Mose Jenkins, Francena and Liz McCants, Hercules, Emily, Elizabeth and Tommy Shubrick, Minnie and Arthur Kennedy and especially Robert McClary, who has now published his memoirs. Information from families of former employees has helped immensely, and they include Lois Massey; Jesse Vereen McClary; Lucille Vereen DeLavigne; The Hay (Donaldson) family; Charlotte Taylor Altman; Isoline Beatty Lucas; Olive Buxton Mancill; Yvette (D'Arthez) and her son Ken Bozigian; and the Caines family, including Shirley Kegley, Myrtle Goldblatt, Goley West and Jerry and Roy Caines.

Mary Miller, biographer of Belle Baruch, generously shared her valuable research, while Linda Ketron and Avis Hutchinson provided encouragement and friendship.

Marcia Dunn, a Hobcaw staff volunteer and retired English teacher, typed, reviewed, edited and strengthened the entire text. Her professionalism proves that one does not retire from the teaching profession nor ever tire of learning. For being my personal tutor and editor, I am grateful.

Hobcaw staff provided critical information and support. Jimmy Bessinger, longtime loyal employee, his wife Carol and sons Bee and Adam, have shared countless hours of conversation, for which I am grateful. Wendy and Dr. Dennis Allen of USC's Baruch Institute have supported and fostered my exploration of Hobcaw's history as they study its ecology. Dr. Charles Gresham, Dr. Gene Wood and Dr. George Askew of Clemson's Baruch Institute led me down forest trails, while Paul Kenny, Bill Johnson and Beth Thomas increased my knowledge of the marsh. Rachel Thomas Stearns, the Baruch Foundation secretary for many years, urged me to put the history on paper. Much credit for this project goes to foundation director George Chastain, who gave me the time and the resources to produce the book. A special thank you is reserved for my coworker Richard Camlin, who loves Hobcaw as much as I do and who invests energy and care in its interpretation.

Finally, I thank my husband and friend Bill Shehan, who knew the entire Waccamaw Neck and "took me to ride" the back roads. His work with the power company enabled him to introduce me to a diversity of local residents and to a variety of special places on the Neck. His sacrifices and love have enabled me to explore, write and record Hobcaw Barony's history.

Introduction

Located at the tip of the Waccamaw Neck between the Waccamaw River, Winyah Bay and the Atlantic Ocean, Hobcaw Barony is a 17,500-acre plantation in Georgetown County, South Carolina. The Waccamaw tribe of Indians called the land Hobcaw, which means "between the waters." Granted as a barony during the colonial era by the King of England to settlers who challenged the tides, hurricanes, dense forests, dark swamps and salt marshes, Hobcaw Barony was sold and subdivided into numerous plantations with names such as Oryzantia, Friendfield, Calais and Michau. Rice, indigo and naval stores were exported as slaves were imported to work the plantations.

Post-Civil War economic decline led landowners to sell their portions of Hobcaw Barony to South Carolina native and Wall Street financier Bernard Baruch beginning in 1905. He used the land as his winter hunting retreat, where family and invited guests sought duck, deer, quail, turkey, fox and snipe and feasted on fish, oysters, clams, crabs, terrapins and wild game. In 1935, Baruch's oldest child, Belle, purchased from her father the northern half of Hobcaw Barony, acreage that included the former plantations of Alderly, Oryzantia, Crab Hall, Youngville, Marietta and Bellefield. An equestrian, sailor, hunter and pilot, Belle left her estate in southern France to build a new home, stable and airport on the former Bellefield Plantation.

By 1956, Bernard Baruch chose to sell the remainder of the barony to Belle, yet he retained a smaller quail-hunting retreat an hour inland from Hobcaw. Belle continued the tradition of hunting in the woods and on the water, but on a smaller scale from that of her father. Just as he had enjoyed the isolation, Belle found the retreat provided privacy, relaxation and an escape from the pressures of celebrity and social obligations. Belle employed descendants of slaves as well as local area whites to serve as security and maintenance staff and hunting and fishing guides.

As Belle grew older, she began to create a plan for Hobcaw Barony's future that would allow the barony to remain undeveloped, thereby providing a habitat for the native flora and fauna. She also hoped that Hobcaw could serve as a place for research and teaching in conjunction with colleges and universities located in South Carolina. In 1964, Belle died at age sixty-

four of cancer, but she had established a multimillion-dollar trust that evolved into the Belle W. Baruch Foundation. Governed by trustees and operated by staff, the foundation oversees the twenty-seven-square-mile preserve for teaching and research in forestry, wildlife, marine science and historic preservation. Permanent laboratories host visiting scientists, teachers and school groups, while members of the public participate in staff-guided programs to expand their knowledge of coastal heritage and ecosystems. Thus, the dream of a woman who knew that Hobcaw Barony was unique has become her legacy.

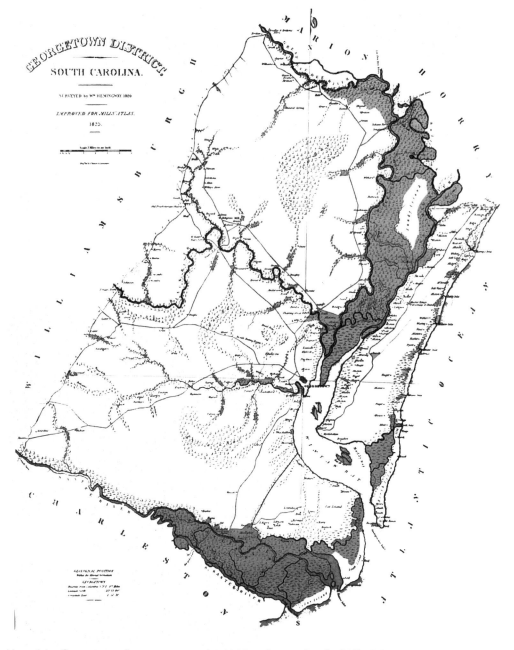

Map of the Georgetown District, surveyed in 1820 and printed in the Mill's Atlas, 1825.

The salt marshes of Hobcaw have fed generations of American Indians as well as European settlers. *Photo by Jane Allen Nodine.*

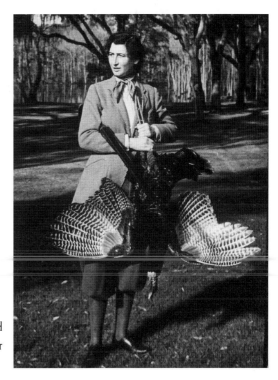

Belle Baruch, ca. 1936, at home on Bellefield Plantation near Georgetown, South Carolina, after a turkey shoot.

Bernard Baruch and daughter Belle, ca. 1957.

1.
Early History

Five million years ago the ocean covered most of what is now called the Waccamaw Neck. Today, amid intensely low lands just above sea level, tidal marshes, vernal ponds and inland swamps, lie gently undulating hills. These sandy ridges are dunes of an earlier age, clearly evidenced by the plants, trees and wildlife found in the environment. Nearly half of South Carolina was an ocean floor about fifty-five million years ago, leaving the state with a sand hills region stretching from Aiken to Dillon and with rare marine fossils in the beds of rivers and creeks fifty-five miles inland.[1]

The varying topography of the Lowcountry was made useful by American Indians who named the rivers Santee (gentle), Pee Dee (shallow), Edisto (black) and Waccamaw (coming and going, or tidal), and who then took their tribal names from the rivers.[2] The Indians were involved in frequent territorial wars, claiming hunting and farming lands and making slaves of the vanquished.

Trading between the tribes of the Lowcountry and those of the backcountry was common. The major roads and interstates in present-day South Carolina are remnants of Indian paths that connected the tribes. Projectile points found on Hobcaw clearly reflect natural stone found in western North Carolina and eastern Tennessee, the land of the Cherokees, and shell material is abundant in those mountain areas.

Native Americans at Hobcaw thrived on deer, bear, turkey, raccoon, opossum, snake, fish, crab, shrimp and shellfish. Shell middens or mounds attest to Indian activity in the salt marsh. Piles of shells and shell rings made of oysters or clams are still a mystery to archaeologists, who debate whether they are ceremonial creations or merely trash heaps.[3] Using available resources for tools, weapons and homes, Indians of the upper coast lived in longhouses constructed of pine timber and palmetto thatched roofs, as evidenced in drawings by John White on the North Carolina coast in 1585.[4]

Native Americans of the Carolina coast encountered Europeans as early as 1526, when six hundred Spaniards under the leadership of Lucas Vásquez de Allyón sailed northward from Hispaniola. Many historians and scholars believe a settlement occurred along the eastern shores of Winyah Bay.[5] Allyón likely brought provisions and supplies such as farming and building tools, weapons, food, cattle, horses, sheep and pigs. The group also

included African slaves, doctors, soldiers and a Dominican friar. Catholics claim 1526 as the beginning of their faith's missionary work in North America. In August of 1526, the Spanish probably entered the present-day Cape Fear River and decided to travel south, some by water and some by land near "the longe bay" or grand strand. The group met on the banks of Winyah Bay.[6]

They proceeded to create a town and a church, but by October the slaves had revolted, the priest had disappeared and their leader had died. The colony was forced to disband and they set sail to return to Hispaniola. With food scarce and the weather freezing, only 150 of the 600 Spaniards survived.

Archaeologists from Coastal Carolina University found it reasonable to assume that Allyón's colony settled on the eastern edge of Winyah Bay, where high ground and deep water provided an ideal location. In 1991, funded by the Georgetown County Historical Society, James L. Michie led a project from Coastal Carolina University to investigate the shores of Winyah Bay, all part of Hobcaw Barony. Extensive archaeological fieldwork yielded no evidence of the settlement in the areas that were searched. However, a natural bluff above the bay, where Hobcaw House, built in 1930, now stands was not investigated because foundation trustees restricted Michie's search to other areas of the property. To date, no evidence has been found elsewhere on the South Carolina coast to refute the theory that the first European settlement in North America was attempted at Hobcaw Barony.[7]

In 1700, John Lawson was appointed by the Lords Proprietors, the colonial governors and representatives of the English King, to make a reconnaissance survey of the interior of Carolina, the colony claimed by the English. Lawson, along with five other Englishmen, three Indian men and the Indian wife of a guide, set out in a large canoe. They hired another Indian, a Sewee, who led their party to the king of the Santees. For "a thousand miles," Lawson explored from Charleston to North Carolina and recorded rich descriptions of Indian villages and ceremonies.[8] At Sewee Bay they feasted on raccoons, deer and wild hogs. The hogs most likely were feral swine, descendants of hogs brought by the Spanish in 1526. They also ate oysters, clams, conchs and cockles and observed turtles, shellfish, waterfowl and shorebirds.[9]

Lawson also noted plants, among them the yaupon or cassena, which reminded him of English boxwood. Yaupon was a valuable Indian trade item and a tea was derived from its leaves and small twigs. The tea, or black drink, served as an ipecac. A ceremonial potion, the tea was believed to purge the drinker's soul of evil spirits. Thus Lawson named the yaupon *Ilex vomatoria.*

Lawson's travels provided a record of the inhabitants, geography, wildlife, flora and fauna of the Carolinas in 1700. Many historians consider him to be the Carolina version of Lewis and Clark.[10]

The Indians along the Waccamaw River traded heavily in deerskins and welcomed English traders from Charles Towne. An early colonial appointee named William Waties Sr. established a trading post by 1716 on a high bluff at Wee Nee (or Wineau) on the ancient Black River. About 1720, Lewis John established another trading post on two

hundred acres of land that he owned on a bluff above the Winyah Bay, where present-day Hobcaw House stands.[11]

English colonists trading in the area took notice of the abundant lands of the local tribes and their hunting and agricultural successes. Word spread that there was good land north of Charles Towne. Early land grants in Carolina were made to representatives of King Charles II, who owed favors to those who had restored him to the throne. Later, George I and II shared Charles's goal to colonize Carolina to make money for the Crown. The port of Georgetown was established, and the former lucrative Indian trade was replaced with naval stores or forest products and their export. By 1730, only three hundred American Indians lived in the Georgetown area, and they were killed or driven out by disease, deceit and warring factions. Most of the remaining Waccamaws moved into eastern North Carolina and merged with the Lumbees or the Catawbas. Some members of the Waccamaw tribe still remain in Horry County, and in 2005 they received legislative recognition as an American Indian Tribe of South Carolina.[12]

Centuries of natural fires created a broad, grassy meadow under a stand of old growth longleaf pine trees. *Photo by Jane Allen Nodine.*

Hobcaw's Strawberry Swamp provides refuge to nesting pairs of American bald eagles. *Photo by Jane Allen Nodine.*

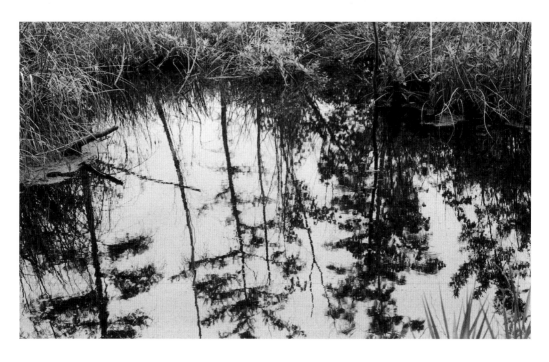

Bald cypress, red maple, water tupelo and sweet gum trees dominate Youngville swamp, an ideal habitat for alligators, snakes, otters, beavers and birds. *Photo by Jane Allen Nodine.*

Bernard Baruch renovated the church in Friendfield Village shortly after his purchase of Hobcaw in 1905 and built a doctor's office for visiting physicians Dr. Francis A. Bell and Dr. Phillip Assey, both of Georgetown. *Photo by Jane Allen Nodine.*

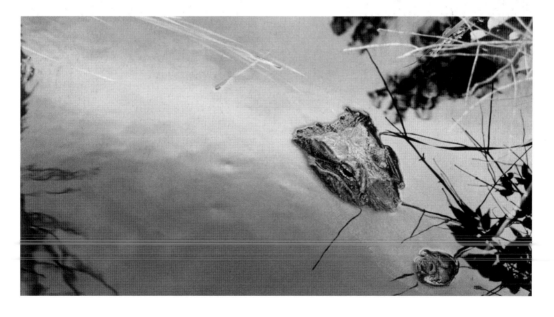

A living fossil, the American alligator is native to Hobcaw's freshwater coastal plain environment. *Photo by Jane Allen Nodine.*

The Colonial Era

In 1711, when free land could be obtained elsewhere in the colony, Alexander Widdicom purchased two hundred acres at Hobcaw Barony from William Rhett. The land backed up to the foot of a major Indian trail, fronted on Winyah Bay and sat behind a large marsh island that offered secluded mooring. From the bluff there is a clear view in all directions. Perhaps Rhett or Widdicom hoped for Spanish treasure, were involved in piracy or merely wanted to establish a trading post. In any event, Widdicom died and by 1716, Lewis John had moved from the Indian trading post on the Black River and had probably established a post on his newly purchased land at Hobcaw. Historian Suzanne Linder believes that this area's typography made the location unique and desirable to Hobcaw's earliest settlers.[13]

Also in 1711, the land the Indians called Hobcaw was surveyed as one of the ten baronies in the colony that were to be divided among the Lords Proprietors. John, Lord Carteret and later Earl of Granville, received Hobcaw Barony in 1718 as a proprietary grant from George I (1714–27), but he never came to America. Carteret was one of South Carolina's eight colonial Lords Proprietors, having replaced his father on the council. He has been described as one of the first orators, a pure patriot, the keenest wit, the brightest classical scholar and the most ardent convivialist of his time. The formal grant allowed Carteret twelve thousand "Acres of Land English Measure situate, lying and being upon Waccamaw River and Commonly called Hobcaw Point, butting and bounding as appears by a plot or plan thereof hereunto annexed."[14]

After twelve years of remote ownership, Lord Carteret sold his 12,000 acres to John Roberts, who had the property resurveyed. In 1736, Roberts secured his own grant from King George II (1727–60) for a total of 13,970 acres at a purchase price of £500. In turn, Roberts sold the land to three men of England who hired a local agent to resell the land. Paul Trapier sold the first tracts in 1766 and within one year had sold all of the Englishmen's land at quite a profit on the investment.

The town of Georgetown was formally established in 1729 and became a port of entry in 1732. Early landowners in the area found immediate success in shipping deerskins, beef

and pork, pitch, tar, rosin and turpentine from the port. England hungered for beef and longed for lumber.

When the first settlers explored the land from southern Virginia to eastern Texas, they had found ninety-three million acres of longleaf pine.[15] Underneath the longleaf forest's canopy, white-tailed deer grazed, turkey strutted and recently stocked herds of beef cattle foraged. Naval store production resulted in lumber for planking, masts for sailing ships and pitch, tar and turpentine for sealing or treating the ships' lumber. By the early eighteenth century, the South Carolina colony was producing more naval stores than any other mainland colony. The manufacture of pitch and tar at Hobcaw is confirmed by the archaeological evidence of tar kilns. Pits were dug and fires set to process the sap from the split logs, while the resin was sweated out of the wood.

Because of the high incidence of merchant shipping and Great Britain's naval strength, colonists were paid a bounty for their naval stores. One man who prospered at Hobcaw was Samuel Masters, who bought out Lewis John's bluff and produced naval stores with his two slaves. He also made barrels, shipped lumber to Georgetown's shipbuilders and raised stock. In addition, he operated a ferry across the bay with rates as follows: ten shillings for one person or seven shillings six pence per person for a group. A man and a horse cost fifteen shillings, although on narrower river crossings, a horse tied to the ferry could swim across for free.[16] By 1737, another mariner named John Richards had purchased the bluff, but called himself a planter. With rice already a major crop and a strong export, many small planters had their sights set on fortune.

When Lord Carteret relinquished his rights to Hobcaw Barony in 1730, many men lined up to buy what were perceived to be productive lands at the southern tip of the Waccamaw Neck. Not only did water border the point on three sides, but a major road, the King's Highway, also ran through the center of Hobcaw. Once an Indian trail, the road was widened during the colonial era and named in honor of the King. The road connected the three major cities of Boston, New York and Charleston. Ferries crossed the major creeks and rivers as needed and were closely regulated by the colonial government, as were highways and bridges.[17] These were desirable tracts of land.

The former barony, as well as other tracts of property on the Waccamaw Neck, were divided from the river to the sea to allow for fairly equal distribution of acreage and of fresh- and saltwater access, timber land and high ground for agricultural fields. With easy access to the port of Georgetown, the land of Hobcaw was purchased and put into production by the late 1760s. Men from England, Scotland, France and Ireland purchased these lands after early careers as merchants, bricklayers, port officials and Episcopal priests. All aspired to gain status in the colonial culture and that meant becoming part of the planter class. Within another decade, most Waccamaw planters would aspire to be independent Americans.

A two-story house was built about 1910 for the Vereen family and was later used by the family of employees William and Daisy Kennedy. *Photo by Jane Allen Nodine.*

A man-made canal divides freshwater rice fields on the western edge of Alderly Plantation, part of Hobcaw Barony. *Photo by Jane Allen Nodine.*

The pond at Bellefield is part of nearly ten thousand acres of wetlands, once part of the proprietary grant. *Photo by Jane Allen Nodine.*

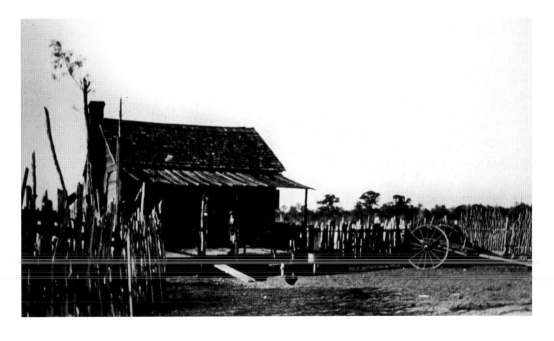

During the plantation era, slave cabins such as this one housed laborers. The photo was most likely taken on Strawberry Plantation, ca. 1905.

The Plantation Era

From the inception of the Carolina colony, crop and product experimentation was common among planters. Various grains and fruits, as well as vineyards, silk, tea, salt, bricks, beef, lumber, indigo and rice, were important commodities.[18] As planters purchased land at Hobcaw, they hurried to turn a profit. Eleven named tracts make up today's Hobcaw Barony. From south to north, the plantations are Calais, Michau, Cogdell, Strawberry Hill, Friendfield, Marietta, Bellefield, Youngville, Oryzantia, Crab Hall and Alderly.

The property, which was purchased in 1767 by Samuel Clegg III, was over three thousand acres. The Clegg land was deeded to subsequent generations of families whose names were Michau, Towner, Chovin, Buford, Porter, Coachman and Fraser. Several family members, including Lydia Towner Coachman, were buried in a small cemetery on the site. By 1796, the original Clegg tract was divided into two plantations. The eastern portion was named Michau and the western portion was named Calais.

Paul Michau's will was witnessed by Hugh Fraser, who came to own both Calais and Michau. Hugh Fraser was a priest called to serve two of the Georgetown area's three Episcopal parishes. He served Prince Frederick Parish, north of Georgetown along the Pee Dee River, and All Saints Parish, northeast of the port and along the Waccamaw River. Prince George Parish was located in the heart of Georgetown, and its original church still stands. Fraser married well, three times to women connected to the ownership of Michau and Calais plantations. He became a planter and in 1796 first used the name Calais because it lay opposite Dover Plantation along Winyah Bay. The reference was a nod to crossing the English Channel from Calais, France, to reach Dover, England. In 1840, Fraser heirs sold Calais and Michau, which were soon in the hands of Alston family members. Among other plantations on the Waccamaw Neck, William Algernon Alston owned Michau, Friendfield and Marietta. By 1850, he was producing 1.8 million pounds of rice, and by 1860 he owned four hundred slaves.[19]

The tract of land just north of Calais was first developed about 1711. By 1731, a ferry operated from this bluff to Georgetown and carried naval stores produced on the plantation. Between 1767 and 1807, the Cogdell name is associated with this land. John Cogdell was

a mariner, the owner of sixteen slaves and the master of a ship, *The Good Intent*, built and registered in Georgetown. He also operated a store and served as a middleman, or a factor for the exchange of shipped goods. John Cogdell was an officer in the Revolutionary War and was elected to the state legislature. He died of influenza on the plantation and is buried in a prominent grave at Prince George Winyah Parish in Georgetown. His land was absorbed into Alston ownership, and rice was produced on its freshwater marsh islands.[20]

Strawberry Hill is the name the Alston family later gave to land bought in 1767 by Benjamin Trapier. A French Huguenot, Trapier was first a bricklayer who turned to planting on this site. During the Revolutionary War he donated three hundred barrels of rough rice to the cause and supplied Francis Marion's men with corn, rations and fresh horses. When he died in 1782, his plantation was divided in half, and the result was Friendfield to the north and to the south, "Belle Voir." Resold several times, the Belle Voir tract was purchased by an Alston in 1804 and renamed Strawberry Hill. A large swamp, which in recent years has boasted an active eagle's nest, served as a reservoir connected to rice cultivation. Alston family members planted rice on this plantation until the Civil War. In 1828, a list of purchased items for Strawberry Hill included whitewash brushes, files for a dove-tail saw, brass door knockers, a feather duster, a rat trap and a dozen shutter bolts.[21] One shell motif shutter bolt, found at the site, is on exhibit at Hobcaw.

Friendfield Plantation was likely named by two brothers, William and John Waties. Once a part of Benjamin Trapier's land to the south, Friendfield was bought in 1787 and, using slave labor, the men planted rice. Both William and John died suddenly in 1789, and in his will John left Friendfield to his fiancée Elizabeth Allston. She accepted the responsibilities of the plantation, hired overseers and gave clear instructions for her slaves' care, education and religious instruction.[22] In 1791, Elizabeth married Dr. Joseph Blyth; they had no children and she outlived him. For fifty years Elizabeth Allston was a woman rice planter, and she served as a role model for her niece, Adele Petigru Allston, and her great-niece and namesake, Elizabeth Waties Allston Pringle, who wrote of her own post-Civil War struggles in two books, *A Woman Rice Planter* and *Chronicles of Chicora Wood*. Friendfield remained in the Allston/Alston extended families until after the Civil War.

The plantation later known as Marietta was created by Peter Secare in 1767. Another example of a tradesman who aspired to be a planter, Secare was a successful plasterer who had lived in the area for nearly thirty years. One commission he fulfilled was replastering the interior of Prince Frederick Parish Church on the Pee Dee River. As a landowner, he probably planted indigo. At the time of his death in 1769, he kept twenty-seven head of cattle.

Perhaps through inheritance or marriage the next owner of Secare's land was Thomas Humphries, a former Methodist minister who "lived palatially, was rich as a rice planter [and] quite popular among the aristocrat."[23] As there is no evidence of rice cultivation, Humphries may have planted indigo here at his Pleasant Fields. A large house once stood at the end of an avenue leading from King's Highway. Records suggest that by 1816, the plantation was bought by an Alston and was renamed Marietta to honor Mary Motte Alston. Her grandson J. Motte Alston writes of keeping a pet deer at Marietta.[24] Motte loved to stay at the spacious one-story house that was set in a grove of pine trees and where

he could fish, ride, shoot and enjoy the woods. By 1847, Friendfield and Marietta were owned by William Algernon Alston, one of the Waccamaw's rice princes.

The land known as Bellefield and Youngville was at first simply known and cultivated as the Robert Heriot tract, where he produced indigo before the Revolutionary War. Heriot fought at the battle of Fort Sullivan (later Fort Moultrie) and was captured and held prisoner in 1780. He returned to planting after the war but died after an accident in Georgetown in 1792.

In 1794, Thomas Young bought and named Bellefield. He also bought the tracts called Youngville, Oryzantia and Crab Hall. Young married, and his residence at Youngville appears on a 1794 plat of structures, with two rows of slave buildings. He hosted his sister's wedding at Youngville in 1797. By 1800, Young's first wife had died, and he married Mary Allston of Brookgreen.

Rice was Young's primary crop, and he dammed a broad creek coming in from the Waccamaw River to create a fifty-two-acre reservoir for the cultivation of inland rice. By 1808, he had built a tidal-operated rice mill.[25] A 1798 plat shows a main house and dependencies at Bellefield, as well as a seashore house on the edge of the salt marsh. Young died at age thirty-four, but he had accomplished much in his short life. He had completed and used two plantation houses, contrary to local legend, which says that his ghost, lantern in hand, wanders through an unfinished house.

Young's widow married an Alston, and Crab Hall, Oryzantia, Youngville and Bellefield were bought by Alston cousins. By 1839, Charles C.P. Alston planted at Bellefield, lived at Fairfield on the Waccamaw Neck and owned a townhouse in Charleston, open to the public today as the Edmunston-Alston House. Also by 1839, Youngville was owned by William Bull Pringle, husband of Mary Alston, who also owned an architecturally significant townhouse in Charleston, the Miles Brewton Mansion.[26]

Oryzantia and its seashore portion, Crab Hall, were once joined and were part of the Robert Heriot tract, later owned by Thomas Young. Young gave his northern holding, stretching from the river to the sea, the name Annandale. Some readers of old maps misread the elegantly handwritten "Annandale" as the name "Armordale."

By 1808, Young's widow had sold the river side of the tract to young Joseph Alston and his bride Theodosia Burr. Perhaps it was she, who spoke seven languages, who named Oryzantia in honor of the rice plant. After his wife's disappearance at sea in 1813, Alston sold the plantation immediately. As early as 1848, Oryzantia was probably absorbed into Mayham Ward's Alderly Plantation to the north. He lived at Alderly and was the son of Joshua John Ward of Brookgreen, who, as one of the largest slave owners in the South, produced millions of pounds of rice.

The plantation that later became known as Alderly had been developed by Robert Heriot in 1766. A native of Scotland, he may have been one of the early rice planters on the Waccamaw who used tidal cultivation instead of inland swamp irrigation. As early as 1738, advertisements appeared for land with "river swamps to make rice fields." Heriot also planted indigo before the Revolutionary War. During the fighting he was captured and held prisoner near Charleston; he was later paroled and allowed to visit his family on their Waccamaw plantations.

Robert Heriot's early death, due to an accident in 1792, resulted in the sale of his tract to Benjamin Huger Jr. Huger was a child when the Marquis de Lafayette and the Baron de Kalb, having arrived in America in June 1777 to aid the Patriot cause, came ashore at his father's summer retreat located nearby on North Island. Later Huger gave the plantation to his half-brother Francis Kinloch Huger, who, while studying medicine in Europe, learned of Lafayette's confinement in an Austrian prison. He and another man orchestrated Lafayette's successful escape but were caught soon after and imprisoned themselves.[27]

Upon his return to America, Francis Huger built a house at Alderly and married Harriott Lucas Pinckney, the granddaughter of Eliza Lucas Pinckney, who was the propagator of indigo in colonial Carolina. By 1848, Huger had sold Alderly to Joshua John Ward, who transferred the property to his son Mayham. During the Civil War, Mayham and his brothers manned an earthwork battery on Hobcaw's Calais Plantation. The fort at Fraser's Point complemented Battery White at Belle Isle Plantation, both located on either side of Winyah Bay. The era of wealth, of rice planting and of slavery was about to end.

Enslaved Africans were utilized as labor in the Lowcountry for almost two hundred years. When the first ships came to Carolina in 1670, slaves were on board. Within a few decades, a direct slave trade from Africa had developed, delivering slaves to Charles Towne dealers from the Senegal and Gambia regions of Africa's west coast. These slaves played a major role in establishing the Carolina rice culture. They were familiar with the growing and harvesting of rice and had lived in a similar climate. Rice was not a European crop, and Native Americans only gathered wild rice. Without the strength and skills of enslaved Africans, Georgetown County could not have become the world's second largest producer of rice. Charles Joyner, in his *Down by the Riverside*, acknowledges that over the years the Europeans contributed their engineering and management skills to extending and rationalizing the system, but the basic methods of planting, hoeing, winnowing and pounding continued as they had been practiced in Africa.[28]

At the plantations of Hobcaw, absentee landlords depended on overseers to accomplish the daily quotas. Tasks were assigned according to age and ability and when those tasks were completed, a slave was free to return to quarters. In their "off times," a slave might work to supplement his meager rations by gardening or by trapping raccoons, rabbits, opossums or squirrels. Limited use of firearms disassociated the slave from deer, duck and turkey. A long walk to the salt creeks usually resulted in a bounty of fish, crabs, shrimp, clams and oysters. Cooking, quilting, tending children and caring for personal livestock were done in the quarters.

At Friendfield Plantation as many as twenty slave cabins may have stood by 1840. All symmetrical and ordered, each cabin housed an average of five family members. A fire in the fireplace provided a cooking space, light and heat. Firewood was abundant, yet demanded another chore to be done at the end of a long day. Work began at sunrise, often because it was cooler, but not all slaves went into the fields.

A definite hierarchy existed among the slaves, with skilled craftsmen having the highest rank. Everything that was truly needed on a plantation could be produced, and so there were all manner of skills needed. At Bellefield, Alderly and Calais, evidence shows there were drivers or black foremen, mechanics, machinists, wheelwrights, millwrights, millers,

carters, coopers, bricklayers and blacksmiths, who made plantation tools, nails and knives. Women, too, shared this hierarchy. Those who served as cooks, maids and nurses in the big house had a slightly improved work environment, but were constantly at the owners' beck and call. Many women served as weavers and seamstresses, laundresses and daycare providers for young mothers who had to return to work.

Plantations were self-sufficient communities, but there was much movement on and off the plantations. Many slaves had privileges to visit nearby plantations. Some slaves carried money and did business in town for their owners who were often away from the plantations.

It was considered virtual suicide for the members of the planters' families to remain near the stagnant waters of the rice fields between May and October. Swamp gases emanating from the lowlands were one theory of the cause of malaria. By escaping to the seashore, with its strong breezes, or to the piney woods, where it was believed the resinous gases counteracted the swamp gas, planters thought they would be protected from the summer or country fevers. Actually it is the anopheles mosquito that carries malaria, and the planters were wise to leave the standing waters of the rice fields. Africans carried a genetic feature— the sickle cell trait—that gave them a partial immunity to malaria. While some did contract the disease, it was not as fatal as it was to whites. Most planters had some medical training, but physicians were usually employed on a contractual basis. Nurses, both male and female, were slaves who operated the plantation hospitals. Dr. Andrew Hasell served area planters and trained nurses and midwives at Cedar Grove, his home on the Waccamaw Neck.

Keeping slaves healthy, or at least working, particularly during harvest time, was of utmost importance. Many hands were pulled away from other chores or brought from neighboring plantations to bring the rice from the fields to the barns. Weather was an enemy, and fall floods, freshets and hurricanes were the most common vicissitudes. The natural rhythms of nature presented another problem, for the migration of the American bobolink coincided with the spring planting and fall harvesting of rice. This tiny songbird flew through the area in such huge numbers that wise was the planter who tended to his bird watching. Young and old slaves served as bird minders, building brushy fires, banging pots and pans or firing bric-a-brac out of old muskets. The "rice birds," which fed off the rice seeds, were also good to eat, and one plantation cookbook offers a Rice Bird Pilau. The other ingredient, of course, is rice.

Rice, grown as early as 1609 in the American colonies, was advertised in a 1678 promotional pamphlet. A Virginia pamphleteer praised the tobacco, flax, rice, trees and timber.[29] In 1697, enough rice, wheat and corn were grown in Virginia to export to New England and the West Indies. Daniel Littlefield, in *Rice and Slaves*, found a remarkable reference in 1650 to experimenting with rice cultivation in the swamp lands and using hydraulic controls. Dutch technology was allowing some success in Italy and England, and experimentation in America was being encouraged.

From dry cultivation to inland swamps, South Carolina landowners began to experiment. The successful elements of ditching and clearing swamps came not just from the labor of the Africans but from their ingenuity as well. Hollow trees or trunks were used as wooden culverts; seeds were not broadcast on the surface of the water, but were "clayed" and buried by a slave's foot; the flailing, pounding and winnowing methods used were also African.

During the eighteenth century, 43 percent of the Africans brought into South Carolina came from regions where rice was an important crop. A positive emphasis was placed on purchasing slaves from the rice regions.[30]

The flooding of rice fields adjacent to the tidal waters of the Waccamaw acted as an aquatic herbicide. Rice could grow under water, whereas weeds could not. Rice prospered along the South Carolina coast, and the Waccamaw River had just the right rise and fall, just the right width and length, to become the top-producing river. Profits were invested in more land and in more slaves; the large rice planter smothered the small planter. Rice mills were built on individual plantations. Privately owned schooners shipped Georgetown's rice directly to Charleston for export. However, the economy and the culture, built on the labor of slaves, could not continue.

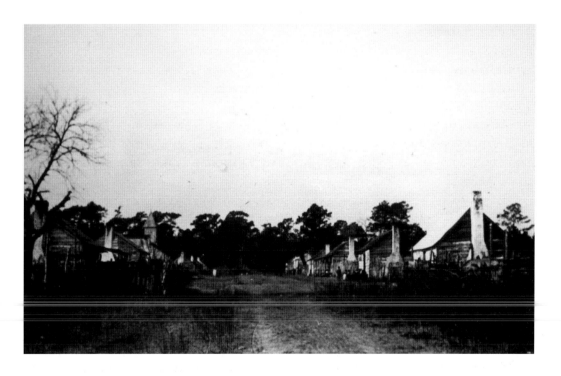

When this photo was taken, ca. 1905, the former slave village on Friendfield Plantation had twelve cabins remaining alongside a church, which had been rebuilt after the Civil War.

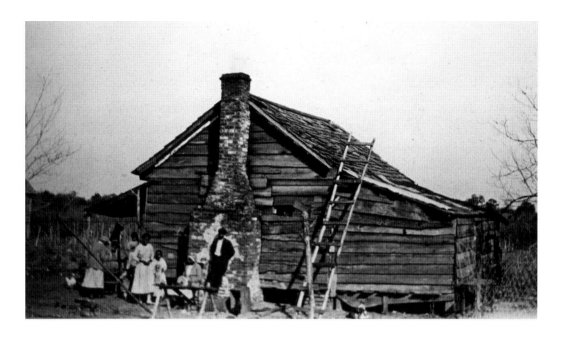

Made of cypress, pine and cedar, two-room slave cabins were enlarged after emancipation to include a second bedroom and a separate kitchen.

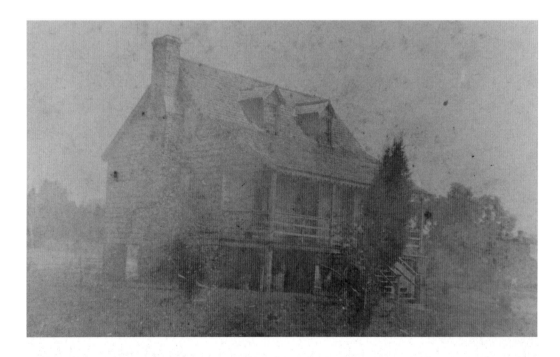

Believed to be Friendfield's main house, this structure first housed owner Elizabeth Allston Blythe, then overseers, and between 1875 and 1894 it was home to post-Civil War owners the Donaldsons. Subsequent caretakers used the house until it was destroyed by fire in 1933. *Photo courtesy of Donaldson family descendants.*

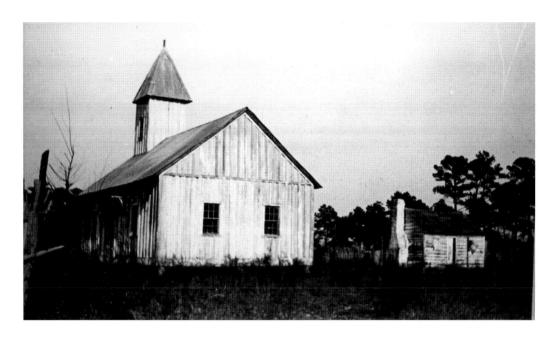

Friendfield Church, rebuilt in 1890, was the religious, social and community center for members of four former slave villages at Hobcaw Barony.

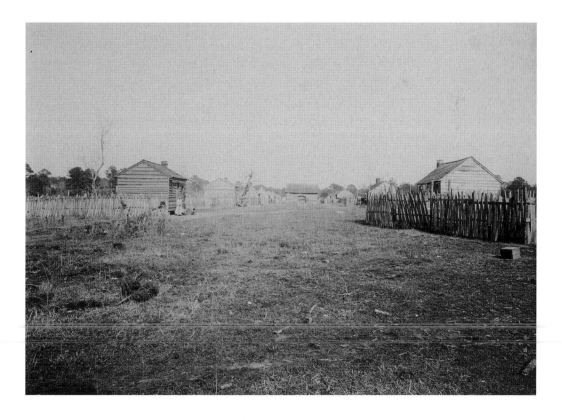

Street view of Barnyard Village on Friendfield Plantation, ca. 1890.

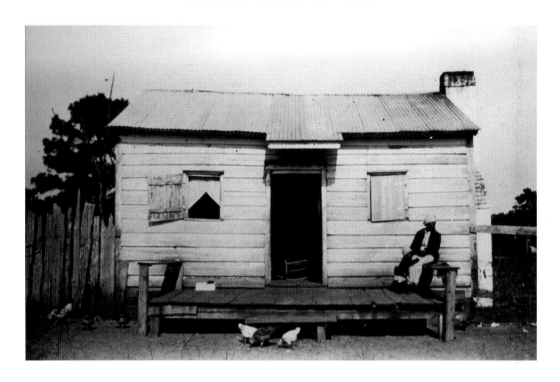

Laura Carr, age forty-seven in this 1905 photo, was born a slave at Hobcaw Barony and lived in Friendfield Village until her death.

At Clambank Landing on Goat Island, a rice planter's summer cabin provided a retreat from the heat and mosquitoes on the river side of Friendfield Plantation, five miles due west.

Timber clearing included not only pines but also live oaks such as these, which are growing on Bellefield Plantation. *Photo by Jane Allen Nodine.*

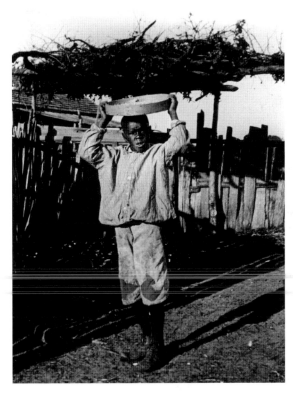

This boy's responsibilities, ca. 1905, were similar to a slave child's duties of tending pigs and dairy cows, gathering firewood and gardening.

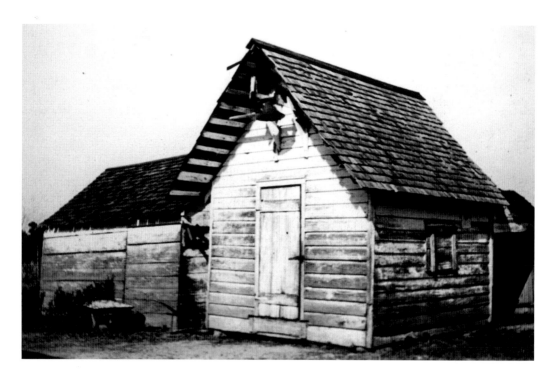

In the plantation barnyard, many outbuildings stored tools, seed and perishables and were kept locked. A bell signaled the beginning and end of a workday.

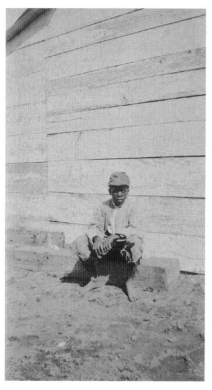

A child on Hobcaw's plantations had work to do, but time for play is evidenced by archaeological artifacts such as different aged marbles found near cabins. Ca. 1905.

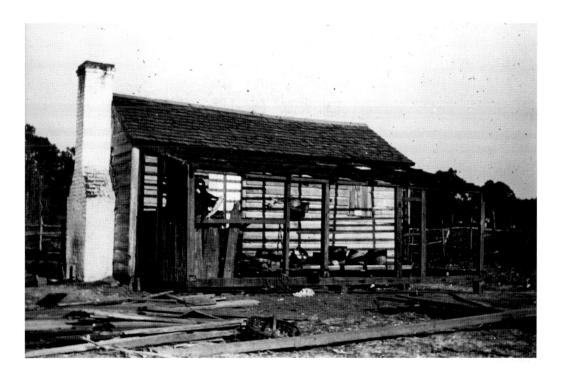

As families grew or multi-generational families began living together, there was a need for more space. New wood and recycled lumber from abandoned slave cabins are being used to add rear rooms in this ca. 1905 photograph.

Charlie McCants Sr., born in 1875 and seen in this 1910 photograph, was a cook at Hobcaw House.

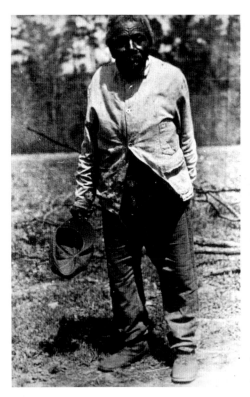

Tim McCants, born in 1850, was the patriarch of a family whose members still visit Hobcaw Barony today.

Hurricanes, floods and fire change and maintain diverse habitats for a wide variety of plants and animals in South Carolina's coastal plain. *Photo by Jane Allen Nodine.*

At Friendfield Plantation, a brick rice mill, which was built in 1858 but burned in 1902, is surrounded by plowed fields in this 1890 view.

The Transition Years

South Carolina seceded from the Union in December of 1860, and by April 1861, war had begun with South Carolina's firing upon a Federal installation in the harbor of Charleston. Many members of the plantation families were directly involved in the conflict. The whites evacuated from their lands and often set fires to barns and supplies as they left. Railroads carried people, livestock and personal possessions inland. Union troops raided Waccamaw plantations and proclaimed freedom to the slaves, but resisted helping them travel to places where they might find aid or work. The Confederacy and her patriotic sons surrendered in 1865 and most Southerners returned to hopeless situations on their land. Planters were in no position to continue the antebellum culture, and upon their deaths, most of their families faced upheavals and inherited insurmountable debt.

William Algernon Alston Jr. owned Hobcaw's Marietta, Friendfield, Strawberry Hill, Cogdell, Calais and Michau plantations, but they had been occupied during the war under the Abandoned Lands Act. In 1865, when Alston returned from military service and took the oath of allegiance to the United States, his plantations were restored, but he died soon after in 1867. In his will he instructed that former slaves Hercules Frazier, "my late father's body servant," and Frank Spring, the former driver for Marietta and Friendfield, be paid annuities.[31]

Some planters or their children returned to rice cultivation after the war, yet only a few succeeded. Production fell from 95,127 tierces of rice in 1860 to 15,000 tierces.[32] Rice was a labor-intensive crop, and the loss of slave labor made its production nearly impossible. Within a few years, competition from western states such as Texas, Louisiana and Arkansas caused the price of rice to drop, so the returns on even a good crop were minimal. At the turn of the twentieth century, a series of weather events wreaked havoc on all agricultural endeavors. Hurricanes, floods, freshets and even droughts between 1893 and 1911 ended the production of rice, once called "Carolina Gold." The last commercial crop of rice was harvested and milled in 1911 in Georgetown County.[33] The machinery rolled to a halt and the barns stood empty.

Just as early settlers had looked to the Lowcountry's resources to provide a living, so did post-war landowners now faced with complete bankruptcy and sale of their land. Political

reconstruction and economic revival created a social revolution; the upheaval came quickly, the revival took a bit longer.[34] The port of Georgetown slowly began to resume shipping and the North Island lighthouse was recommissioned. Exports were mainly lumber and naval stores. Impoverished landowners at Hobcaw and throughout the district turned to timber harvesting once again for revenue. Shipbuilding returned to Georgetown after a one-hundred-year absence, and several ships were built on the Waccamaw River at Waverly Plantation, the site of the last of the rice mills. Port improvements and the promise of a railroad led to investments and to the growth of related businesses, but these measures of hope were not enough for most plantation owners on the eastern shores of Winyah Bay.[35]

The Alston heirs sold the lower lands of the barony to Robert J. and Eliza Donaldson in 1875. A few other holdings were added in 1889.[36] With the help of his grown sons, Donaldson hoped to resurrect rice cultivation on Michau, Calais, Cogdell, Strawberry Hill, Friendfield and Marietta Plantations. Donaldson died in 1894, but his sons continued rice planting.

The Donaldson Bros. Rice Mill was built in 1858, and John Henry and Sidney Townley Donaldson were still operating it when it caught fire and burned in 1902. The night watchman was asleep at midnight but was awakened by the blaze. Plantation hands tried in vain to save the mill, "which was one of the oldest and best buildings in the county—a landmark—and intended for pounding as well as threshing, it was made of brick, with iron doors and window frames, and cost considerable money," according to the *Georgetown Times*.[37]

The Donaldson brothers also leased the less productive rice fields of Michau and Calais to hunters in the 1890s, one of whom was Hartwig N. Baruch, the older brother of Bernard. Another guest hunting on Michau was President Grover Cleveland, who came as a guest of the Annandale Gun Club. He had come to South Carolina in 1896 to hunt duck. The club had under its employ one of the area's top guides, Sawney Caines, who took the president to one of the choicest sites on Michau Plantation and rowed Cleveland to the marsh. Once the boat was concealed with palmetto, Caines set out the decoys. Then he escorted the president to his stand over the thick mud of the marsh. Not realizing that he had to step quickly and lightly, the 250-pound president sank up to his knees in the pluff mud. Caines struggled to get his arms around Cleveland and was able to pull him out of his boots and get him back to the boat. After cleaning up and "taking a little medicine," the president began to shake with laughter. Caines was relieved, but in the many times he retold the story, he never cracked a smile.[38]

Sawney Caines and his brothers Ball, Pluty, Hucks and Bob were all expert guides, commercial fishermen and gunners, but are best known for their legendary decoys. According to national collectors, the Caines are the only known historic South Carolina decoy carvers. In the Lowcountry area since 1830, the family was probably on the barony for three generations. They worked on rice plantations and after the war worked as watermen. The brothers served as hunting guides to many hunt clubs that had taken post-Civil War leases on former rice plantations.[39]

Ducks had always migrated south each winter after harvest and returned north before time to prepare the fields. The ducks came to the area not for the rice, but for the wetlands habitat. Therefore, as rice cultivation ended, landowners realized another resource they

could exploit. Some of the best duck hunting in the United States was found along the Lowcountry's tidal rivers.

The Wall Street financier Bernard M. Baruch, a sportsman, hunter and millionaire, was hearing stories of President Cleveland's trip and of the men in the hunt clubs along the Carolina coast. His Kaminski cousins of Georgetown and his brother Hartwig Baruch also hunted on the barony. At their suggestion, Bernard Baruch decided to accept the Donaldsons' invitation and find out for himself if the "hundred duck days" were myth or reality.

In 1904, Baruch was a guest at Friendfield, the name the Donaldsons had chosen for their holdings, and hunted over the rice fields and salt marshes at daybreak. He felt it was some of the best ducking to be found anywhere. The sky was black with waterfowl, and sixty-odd shells could bring down forty-five ducks. No bag limits existed at that time and no one knew when to stop. Baruch called it a veritable "Shangri-La" and declared the land the most beautiful spot in the world. He felt he had found the retreat he had been searching for after nearly eight years. Baruch shocked his hosts by offering them whatever price they asked for their land.[40]

The Donaldson brothers were examples of post-Civil War owners, a younger generation struggling to make the land profitable. Georgetown County had gone from being one of the richest districts in the nation to one of the poorest. The real estate market reflected the weak economy, and the Donaldsons' asking price for 10,000 acres was a mere $20,000. Baruch's subsequent purchases of plantations contiguous to the north brought the average purchase price to $3.15 an acre for 17,500 acres. Between 1905 and 1907, Bernard Baruch amassed nearly all of the original proprietary grant and Hobcaw Barony was reborn.

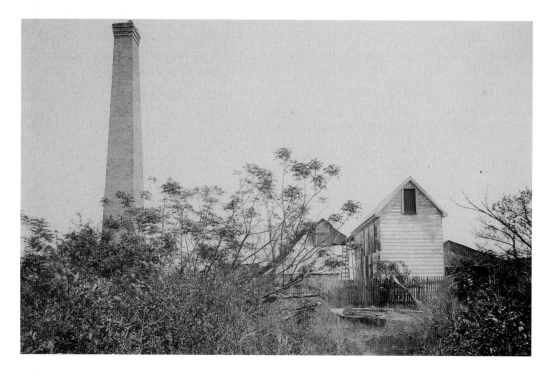

The rice mill chimney, part of a steam-powered mill created on Friendfield in 1858, is seen here, ca. 1890.

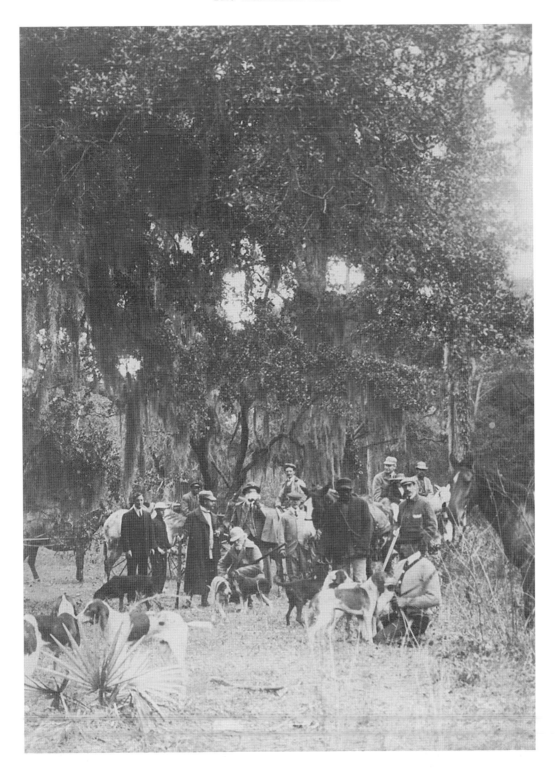

A ca. 1907 hunt scene at Hobcaw features guests, plantation managers and African American staff members. Kneeling, with the white beard, is Dr. Simon Baruch; kneeling in the foreground is Harry Donaldson, superintendent; and seated on horseback is Bernard Baruch with his daughter Renée.

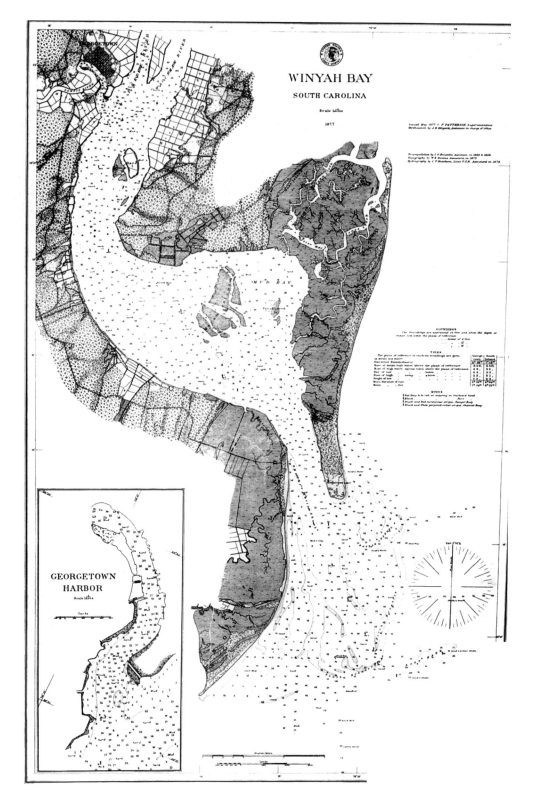

An 1877 map of Winyah Bay, with an enlargement of the port of Georgetown, shows rice fields still under cultivation.

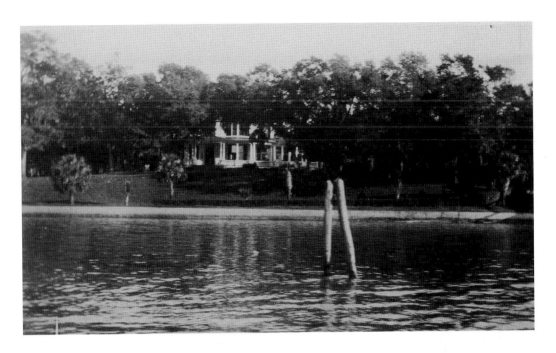

This house, built ca. 1890 by the Donaldsons, became the main house and was located on a bluff overlooking Winyah Bay.

Leases of marshland to Northern hunters often included nineteenth-century plantation buildings, such as these at Clambank Landing, and resulted in large numbers of ducks. Duck hunting was unregulated until 1918.

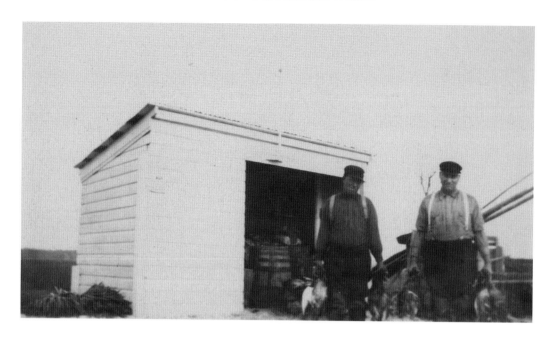

Sawney and Hucks Caines worked for Bernard Baruch until the 1920s and became known nationally for their knowledge of the Lowcountry's woods and waters.

Setting Caines decoys before sunrise and then retrieving them by eleven o'clock resulted in attracting and bagging an average of one hundred ducks per day.

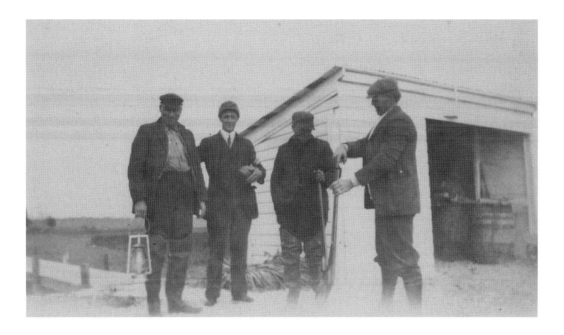

Hucks Caines, seen here with lantern, was Baruch's favorite guide and storyteller. A guest cradles a Caines decoy while Sawney and Jim Powell discuss the barrels of a shotgun. Ca. 1910.

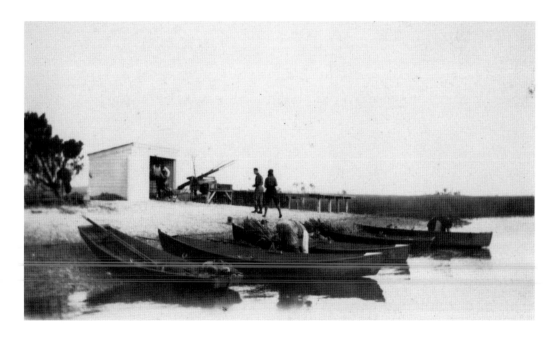

Small boats, or bateaux, were poled through the marsh by African Americans to retrieve downed ducks, as dogs' feet were too easily cut by oyster shells.

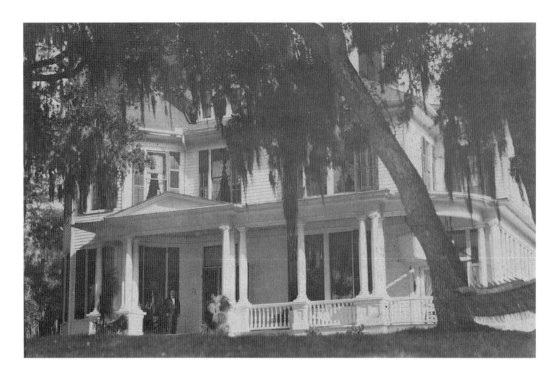

In 1905, Bernard Baruch purchased the lower half of Hobcaw Barony, including the Donaldsons' main house on the bluff.

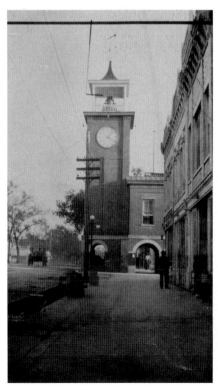

Georgetown's clock tower and city hall dominate Front Street as a horse-drawn wagon heads east in this ca. 1905 view.

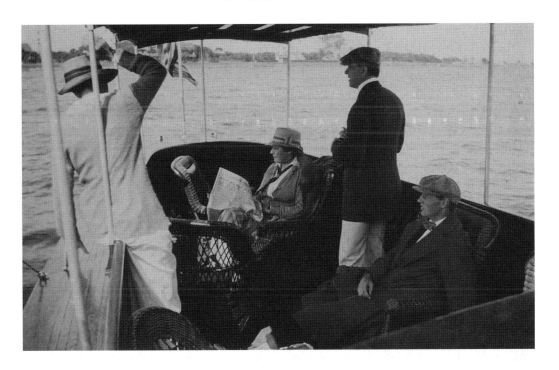

Annie Griffen Baruch in the bow of a yacht with a New York newspaper, ca. 1916. She often traveled by boat or train to reach the family's isolated South Carolina retreat.

Bernard Jr. aboard the yacht with a magazine, ca. 1913, as a Griffen cousin looks on.

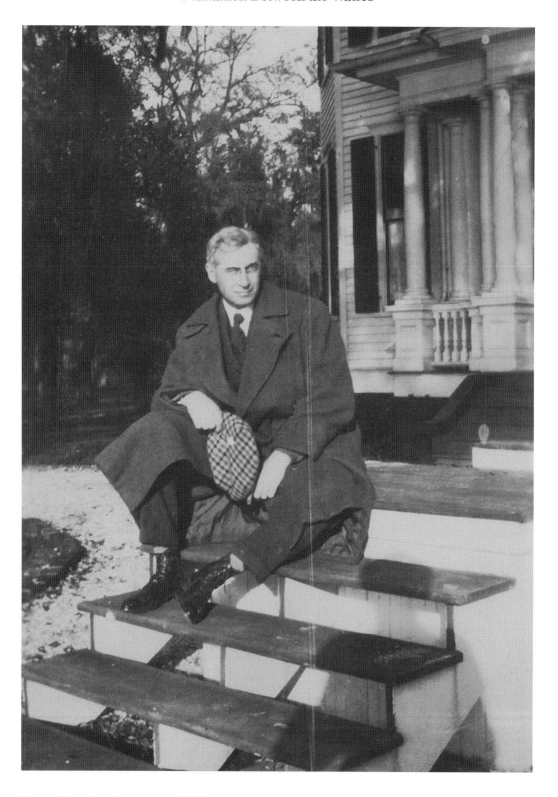

Bernard Baruch on the mounting block at the front of Hobcaw House shortly after his purchase of the entire barony in 1907.

The Baron of Hobcaw

The idea of creating an aristocratic estate to serve both as a retreat from the pressures of a Wall Street career and as a hunting lodge at which to entertain his extended family and inner circle of friends was appealing to Bernard Baruch. Reinforcing this idea was the fact that the property was located in the state of his birth, South Carolina.

Bernard Mannes Baruch was the son of a poor Jewish immigrant and the grandson of a blue-blooded South Carolina slave owner. He was a Southerner and a Northerner, a capitalist and a democrat, a lover of the urban pace and an adherent to the country life. These opposing traits proved valuable to a man involved in politics and business.

Baruch's father was born in Schwersenz, a small, intellectual village near Posen, which was a province in Prussia until 1871 when it became part of the German Empire. Simon Baruch was thought to be descended from Baruch the Scribe, who edited the prophecies of Jeremiah and whose name is given to one of the Books of the Apocrypha.[41] His parents spoke German and sent young Simon to be a student at the Royal Gymnasium in Posen. He was interested in medicine, but since he was Jewish, it was unlikely that he would be able to continue his studies or ever practice medicine.

In 1855, Simon faced conscription in the army, and his parents realized that few Jewish men returned from military service. Plans were made for him to emigrate to America—to Camden, South Carolina—where a former villager, who operated a store, had sent letters of encouragement to Simon's family and friends. Mannes Baum welcomed the sensitive, scholarly Simon and employed him as a bookkeeper while he studied English and American history. Five years later, Baum was able to finance him to classes in medical school in Charleston and Richmond, and upon graduation in 1862, Simon felt compelled to join the Confederate army and to serve beside the sons of the Baums. "South Carolina gave me all I have. I'll go with my state."[42]

Simon Baruch was commissioned an assistant surgeon in the army and served the sick and wounded in at least ten major battles. Other surgeons were surprised that Simon took the time and energy to wash his hands and scalpel before performing surgery. He was twice taken prisoner, but near the end of the war he organized field hospitals in areas of North Carolina affected by fighting with General William T. Sherman.[43]

Sherman had marched through South Carolina by this time and had destroyed the plantation of Isabelle Wolfe and her family. Bernard Baruch's mother, "Belle," was fifteen years old in 1865 and had grown up in Fairfield County, north of Columbia, as the oldest of thirteen siblings. Her father owned twenty-four slaves, several plantations and one large mansion. Her grandmother had once danced with Lafayette, and her grandfather was the rabbi of Charleston's Sephardic congregation, Kahal Kadosh Beth Elohim, founded in1749 and considered to be the mother church of the Jewish Reform movement.[44]

Belle Wolfe's ancestors were in America by the 1690s and one, Isaac Marques, captained a ship that carried slaves from Africa to New York. Her aunt lived in Camden and was married to Mannes Baum. A young clerk in their store caught her eye, and after his return from the war, Simon and Belle were married in 1867.

Dr. Simon Baruch bought a three-acre farm in Camden after the wedding. Belle taught piano and voice lessons and sold milk and butter produced by their own herd of cows. The house was a Charleston-style single house and was soon filled with four young boys, Hartwig (1868–1953), Bernard (1870–1965), Herman (1872–1953) and Sailing (1874–1962). They had a black nanny named Minerva, ran barefooted to the factory pond and played baseball in the dusty streets of the small Southern town. Dr. Baruch most often received bartered goods for his services in treating the sick, including a ham, a basket of vegetables and a cord of firewood. His sons enjoyed their pet, a small dog offered as payment for Dr. Baruch's delivering a baby. His medical practice was a successful one, and Dr. Baruch was considered a community leader. On a larger level, he was active in reestablishing the state medical societies and organizing meetings. But it was also a difficult time. The Reconstruction era was one of corrupt government, unemployment, poor health practices and a general lack of cash.

One other social problem plagued the post-war South—violence. The Deep South was occupied by Federal forces until 1876. Blacks and whites struggled to establish a new social order, and dueling was still a common way to solve disagreements. The infamous Cash-Shannon duel involved two prominent Camden area residents, Ellerbe Bogan C. Cash and local attorney William M. Shannon. Shannon's death and Cash's subsequent exile from the community convinced state leaders to create and enact laws ending dueling in South Carolina. Dr. Baruch witnessed the duel while waiting for the sheriff to arrive and end it but could not save Shannon's life. Disheartened by the lack of law enforcement and the undercurrent of violence, Simon and Belle decided together that the time had come to seriously consider a move to New York.

Primarily because of the violence, but also for economic reasons, the Baruch family moved to New York City in early 1881. The population of the city was greater than that of the entire state of South Carolina, running water was available and elevated trains rumbled overhead. Bernard Baruch, then only ten years old, was awestruck and frightened by his new surroundings but was buoyed up by the bravery of his older brother.[45]

The boys attended public schools, and their mother became active in the synagogue and in clubs. Dr. Baruch advanced professionally, became a pioneer in hydrotherapy and established the first public baths in the United States. He also became a tireless reformer in health, sanitation and drinking water issues in an urban setting. The family became acclimated to their new environment and were comfortable in New York City.

In the fall of 1884, Bernard Baruch entered the tuition-free City College of New York, which opened its doors for the underprivileged but talented youth of New York. Hard work, both in and out of class, was expected. Baruch worked for his father and at odd jobs, walked forty-three blocks to school and finished academically in the middle of the class of '89. The president of the college urged him to consider West Point, but physical examinations revealed that Baruch was deaf in his left ear, a result of a college baseball episode. In later years he mused that he might have been a general, but despite his lack of military service, Bernard Baruch was a public servant to seven presidential administrations.

Baruch began to court the beautiful, strikingly tall Annie Griffen, who traveled in her own horse and carriage and whose wealthy father was in the glass importing business. Benjamin Griffen had been a student at the City College of New York, and his son was a student there at the time of Baruch's introduction to Annie. The couple rendezvoused in Central Park and courted seven years before Baruch was established enough in business to ask for her hand in marriage. Benjamin Griffen disapproved of the union, although not because of Baruch's career as a speculator—a gambler—on Wall Street; instead his reluctance to accept the marriage was based on Baruch's being a Jew. Annie's great-grandfather was an Episcopal minister, and Mr. Griffen opposed the intermarriage of Christians and Jews.[46] Thrilled that Griffen's reluctance was "nothing personal," Baruch pursued the engagement and, after entering into several successful sugar ventures and becoming a junior partner in his firm, he and Annie married over her father's objections on October 20, 1897.

The newlyweds lived briefly with Dr. and Mrs. Baruch, but between 1897 and 1900, Baruch's fortunes swelled to one million dollars. With such a promising career, the young couple was able to create their own comfortable home life, and Annie was rewarded for the many years she had loved and believed in Bernard as she waited for him to marry her. Their three children were born shortly after the wedding. Isabel Wilcox (1899–1964), Bernard Mannes Jr. (1903–1992) and Renée Wilcox (1905–1995) enjoyed the love of two large extended families and vacationed at Dr. Baruch's summer home in Long Branch, New Jersey, and reveled in their Scottish heritage on vacations at Fetteresso Castle. Bernard and Annie agreed that their daughters would be baptized in their mother's faith and that their son would make his own decision as an adult, but all three were raised as Episcopalians.[47]

The children had nannies and tutors while their parents traveled by steamers to Europe. Letters and telegrams show that sometimes on birthdays Annie was separated from her children. From the Hotel Colorado in Glenwood Springs, Colorado, Annie wrote to Belle:

My darling daughter, You must not think because I have not written you that I have not thought of you very often. We all mention your name everyday, and grand-pa is mailing you a book filled with little donkey pictures which I know you will enjoy. We are all very sorry not to be able to be home on your second birthday but tell Auntie Lenora to have Kurrus [sic] make you a big cake with three candles and…you must cut it yourself. Your devoted mother. August 12, 1901.[48]

Bernard Baruch was a thirty-five-year-old millionaire when he purchased his winter retreat at Hobcaw Barony. Despite the many hunt clubs and groups of visitors, he was the first Northern individual to purchase a winter home in Georgetown County. Others followed suit and purchased land at rock-bottom prices in order to hunt over the abandoned rice fields and upland pastures, in the woods grown full with pines and in swamps dark with cypress. The wildlife and the climate were attractive to wealthy Northern industrialists, and by 1935, scarcely a Lowcountry plantation was still in the hands of a South Carolinian.

Bernard Baruch was returning to his native state, and he relished the opportunity to be part of the landed Southern gentry as the baron of Hobcaw. He and Annie utilized a tall, white Victorian-era house that towered over Winyah Bay. From the bluff the family could survey the port of Georgetown and the five rivers, the Waccamaw, the Great Pee Dee, the Little Pee Dee, the Black and the Sampit, which combined to create Winyah Bay. The house was built shortly after 1890 by the Donaldsons, who were the post-Civil War owners of the southern portion of Hobcaw. Dubbed "the Old Relick" by the three children, as evidenced in their letters and scrapbooks, the house was enlarged with a sun parlor and a wraparound porch. Former employee of the family until the mid-1940s, Lois Massey, the daughter of the Baruchs' superintendent of plumbing and electricity, remembers that the house also boasted bathrooms and new wiring.

Big potbellied stoves sat in each upstairs hall, and there were hot-blast stoves in each room. The Baruchs' winter visits were also warmed by fireplaces in all the downstairs rooms. The fireplace in the enclosed sun parlor could burn logs six to eight feet long. There was always a house full of school friends and cousins, and Lois Massey remembers that sometimes as many as twenty-four people were seated for dinner. She laughed when she remembered preparing oysters on the half shell for such crowds.[49]

It was in this house that Bernard Baruch's hospitality became so famous. The Hobcaw guest books, kept between 1905 and 1956, record the names of luminaries of the first half of the twentieth century. Presidents, first ladies, politicians, premiers, prime ministers, generals, admirals, journalists, actors, writers, poets, columnists, businessmen—everybody who was anybody coveted an invitation to Hobcaw Barony.[50]

Tales of successful hunting in Baruch's domain amazed his friends in New York and Washington, and most clamored to come see for themselves. Nothing could equal their delight when, at Hobcaw Barony, they saw the skies blacken with waterfowl. Hundreds of thousands of ducks overwintered in Georgetown County and "hundred duck days" were legendary. Margaret Coit writes in *Mr. Baruch*, "Nothing was like the beauty of the ducks rising, tracing in the sky the pattern of the creeks and whence they came. To the east in the eye of the sun could be seen flock after flock breaking out of the swamps and rice fields, darkening the sky."[51]

Depending on the tides, hunters might leave from the main house before sunrise with thermoses of soup and sandwiches wrapped in wax paper or wake up in the hunt cabins at the edge of Clambank Landing and have a breakfast of steak and hot coffee. After the hunt, the entourage returned to the big lodge, kicked their boots off and warmed up and snoozed in front of the huge fireplace. A ride out for quail or an afternoon of turkey hunting might

precede the formal dinner with the consummate host presiding. Baruch loved nothing better than sharing this paradise with friends.

It was not unusual for those seated around the dinner table to hear the hounds announce that a fox had been scented. Chairs were pushed back, and guests hurried out into the moonlight and mounted horses for a fox hunt. Each New Year's Day, South Carolina's governor was invited to officiate over deer drives on horseback. A game manager and his mounted crew would herd the deer into the swamp, and guests were guaranteed a kill that day. Early on, this type of hunt ended at Hobcaw, but later, several days on the hunt for game were often topped off by a barbecue, dove pilau or an oyster roast, set up by the staff right in the hunt field under the spreading oaks or the old growth longleaf pine.

Wild turkeys abounded in such numbers that often a buggy was stopped on the dirt road to let them pass. The wild pigs that inhabited the property could be vicious, and a standing order to shoot to kill was issued. Rumors flew about encounters with bears, alligators, panthers and bobcats. Terrapins were kept in turtle pens between the main dock and the boathouse, and the bays, rivers and marshes teemed with flounder, trout, bluefish, bass, mullet and shad. Oysters, crabs, clams and shrimp all made their way to the table. Most of the food served at the barony was gathered or grown on the plantation. Although Baruch attempted rice cultivation on two thousand acres, he always felt that he was merely baiting the field for ducks.

The only wild game that remained elusive was the snipe, a long-billed bird that lived in the marshy areas. The snipe hunt has a venerable and longstanding reputation as a practical joke used to initiate a first-time visitor to a hunting lodge or a summer camp. Baruch delighted in describing the ease of snipe hunting. Rather than the arduous task of stalking and chasing deer, duck, turkey or pigs, the hunter was told he could merely whistle and the snipe, attracted by a lantern in the dark of night, would fly into an open bag. The snipe hunt was much discussed before it finally took place, so by then, the unsuspecting first-timer may have wagered a large sum on bringing in the greatest number of birds. A hunting guide took the visitor to a likely place and other staff served as "beaters," making noises and thrashing the undergrowth to flush the snipe. As the lone hunter whistled, the rest of the group tried to stifle their laughter until the newcomer caught on and came in empty handed. With good humor, the initiate became a member of the Hobcaw Snipe Club, which included, according to Baruch, "leaders of finance, industry, law, letters and state craft."[52]

Another bird that became increasingly elusive was the quail, which prefers open forest floors or farmers' fields. As the forests of Hobcaw were claimed by brush and vines, Baruch sought out quail habitat a few miles inland. Near Kingstree, in Williamsburg County, he first leased and then purchased acreage he named Little Hobcaw. Within an hour, the host and his guests could have some of the finest bird hunting in South Carolina.

Annie Baruch also enjoyed the early years on the plantation, when the children were young and their friends and cousins were invited to visit. A city girl, Annie was a little less daring than her daughters and son. She, as well as her husband and children, was tall; all were six feet or over. Although not a good shot, Annie was a good rider and enjoyed walking or

riding in the woods. She expected the staff to run the household properly. In addition to the one hundred or so Hobcaw residents who served the family, the Baruchs traveled with a European-trained staff that stayed in the house. These employees often arrived at the barony a week before Thanksgiving, opened up the house and remained until after Easter to close up the Old Relick for the season.

Family and guests often traveled on the Baruch yacht, *The Eagle Point*, or arrived in the area by railroad. Baruch owned two private rail cars and often invited associates to travel with him from New York or Washington down to Hobcaw for the weekend. The terminus was Lane, South Carolina, thirty miles inland, until a spur to Georgetown was built. The train station was located at Front and Fraser Streets in Georgetown. Hobcaw staff would pick up guests at the train station and transport them to the docks, where they would board the smaller *Sea Dog* to cross the bay. The trip from New York or Washington was time consuming, but the Baruch family had chosen this secluded retreat to be an escape from social and business pressures. Baruch refused to install telephones at Hobcaw, relying instead on mail and telegrams delivered twice daily in a leather mailbag. Captain Howard Buxton was superintendent of the boats between 1917 and 1936 or so, and he had an able assistant in George Shubrick.[53] A speedboat, *The Chick*, which was the children's nickname for their father, was a Christmas gift from the Baruch children. It was kept at the ready for Baruch, "who loved speed, whether it be his race cars, race horses, boats or incoming information."[54]

A great number of people were needed to keep Hobcaw Barony operating, both in and out of season. One of the blessings of the Northern takeovers of so many former rice plantations was the number of opportunities they provided for employment. When Baruch purchased the barony, he told the one hundred or so freed slaves, their children and grandchildren that they could continue to live on the property and work for him. Most accepted his offer and remained in the villages of Friendfield, Strawberry, Barnyard and Alderly. Even though the positions, such as stablemen, boat handlers, gardeners, farmers, maids, cooks and laundresses, were not that different from the era of slavery, most of the blacks grasped this opportunity to make a living in familiar surroundings.[55]

A major difference, too, was that the blacks were free to leave the barony. Some chose to go and make lives elsewhere, but they kept strong connections to the plantation.[56] To this day, many of these former residents and their descendants return to Hobcaw with their own children and grandchildren; some share in special programs and some return to be buried on the property. Many African American families can trace their lines to the four villages that existed into the twentieth century. Names like Jenkins, Kennedy, Shubrick, McClary, McCants and Carr are still spoken, still overheard, still welcomed.

The Baruchs also hired local white men to serve as superintendents and to live on the property for maintenance and security purposes. Big Jim Powell, who at six feet four inches was as tall as Baruch, had worked for the Donaldsons and "came with the place." He was the sole source of law and order for many years. Powell openly confronted the Caines brothers, who continued to hunt over the land as a challenge to Hobcaw's new owner in 1905. Baruch thought of these men as trespassers or poachers. When the Caines were told not to hunt on the property, they questioned Baruch's ownership of the land

and their being denied the right to continue to make a living on it. Their family had lived on the barony for generations, and their relationship with the new owner was tenuous at best. Undaunted by the interloper, the Caines brothers continued to hunt and fish on the property, so Baruch offered the men jobs as hunting guides. Four of the five brothers agreed, but the oldest refused.

Ball Caines nearly killed Baruch in an encounter at the boat landing. After being arrested and held nine months in jail for poaching, Ball came looking for Baruch. Ball approached him at the landing, and Baruch walked straight up to him. Ball cursed as he aimed his double-barreled shotgun at Baruch. Suddenly Jim Powell appeared from nowhere with a big six-shooter in his hand. This moment of distraction was all that was needed. Jim Powell had saved the day and a grateful Baruch rewarded him with a permanent position as head superintendent.[57]

Baruch depended on the expertise and knowledge of the many local men he employed to run different areas of Hobcaw. Joe Vereen of Horry County came to be the superintendent of the woods, and Joseph F. Lucas was the first superintendent of boats before Captain Buxton. Samuel T. Massey supervised the water and power plants, while Bill Kramer managed the kennels and the grounds of Hobcaw House. J.B. Morris was a maintenance foreman; Floyd Brown was a "deer keeper and watcher"; and John Power Wilson was a watchman. Morgan Shuler assisted the superintendent of timber, M. Lenton Boykin. Howard Dorn was timber manager before and after Hurricane Hazel. These men lived on the property in houses built to accommodate their families.[58]

As a philanthropist, Bernard Baruch gave money to a variety of projects throughout South Carolina. He built or offered to build hospitals in Camden and Georgetown, he financed the Simon Baruch Auditorium at a medical college in Charleston and gave land for the construction of a neighborhood playground in Georgetown. He contributed money to colleges and universities and established individual scholarships. He funded a state commission that researched iodine in the soil and its connection to truck crops, and he also tried to introduce scientific farming methods to the residents of the plantations. As a stockholder in thirty-five South Carolina banks, Baruch tried to help farmers through the boll weevil crisis. The significant demands of owning and operating his shooting preserve resulted in Baruch's employing one hundred persons; purchasing equipment, services and supplies; and paying property taxes on 17,500 acres of land—a huge impact on the local economy.

The Baruch family also financed health care and education for plantation employees and arranged credit at a local store for elderly and infirm residents. Baruch operated two elementary schools on the property: one in Strawberry Village educated the children of black employees, and one at Bellefield was organized for the children of white employees. Baruch hired black and white teachers, provided materials and allowed his daughter Belle to serve as the self-appointed truant officer.[59] Baruch also offered a college education to any student who had potential. More than once he followed through on his offer, sometimes after a reminder from an assertive student.[60] On many occasions he arranged jobs in New York or Washington for the young people from Hobcaw.[61]

Baruch explained that there were several reasons he established a second home in the South. His mother had requested that he remain in touch with the land of his forebears, that he try to aid in its regeneration and that he "do something for the Negro."[62] Baruch felt a deep association with the land, but perhaps he did not realize how much he loved Hobcaw Barony until after tragedy struck.

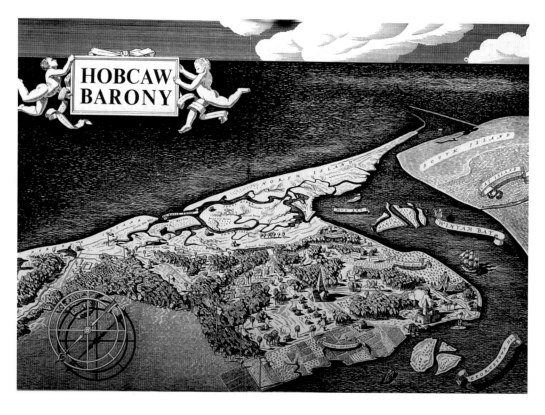

Well-known illustrator Rockwell Kent visited Hobcaw for three weeks in 1927 and created this humorous aerial view, which includes a king, a castle, a columnist named Krock and medieval flags marking the northern boundary of the barony.

On a ca. 1910 postcard, Bernard Baruch poses behind a typical day's bag of one hundred ducks.

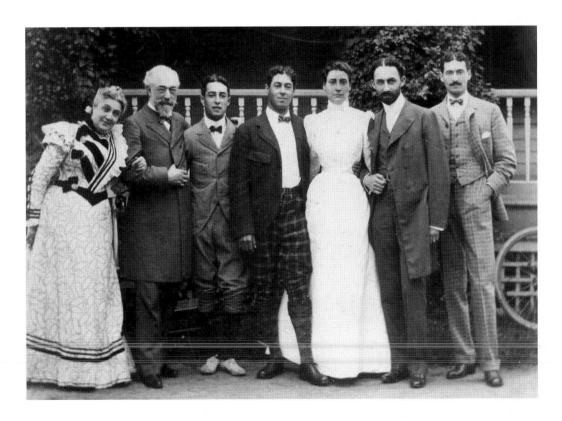

Bernard Baruch (far right) in 1897 with his family. *Left to right:* His mother Belle; father Simon; brothers Sailing, Hartwig and Herman; and new wife Annie Griffen Baruch.

"Grandfather Baruch," in Belle's 1916 photo album, on the porch of the Old Relick overlooking Winyah Bay.

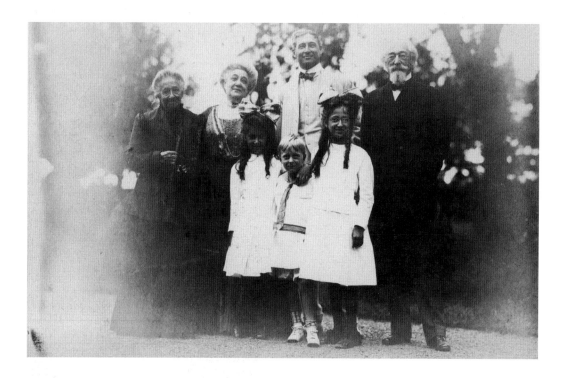

Four generations gathered at the family summer home at Longbranch, New Jersey, ca. 1907. *Left to right:* Sarah Cohen Wolfe, her daughter Belle Wolfe Baruch, grandson Bernard Baruch, son-in-law Simon Baruch and three great-grandchildren.

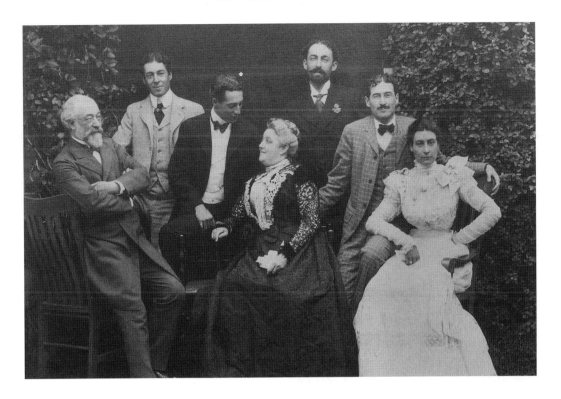

Flushed with success, Dr. Simon Baruch poses with his family ca. 1899. *Left to right:* sons Hartwig and Sailing, wife Isabelle, sons Herman and Bernard and daughter-in-law Annie Baruch.

Dr. Simon Baruch admires his granddaughter, Isabel Wilcox Baruch, whom he delivered a few weeks earlier at his Longbranch, New Jersey, summer home.

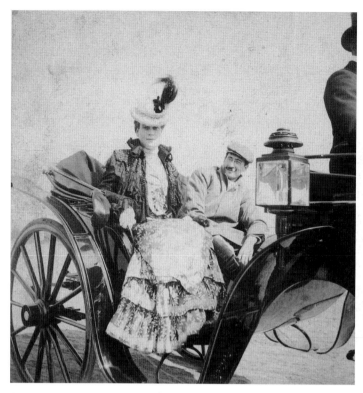

Annie Griffen's beauty caught Bernard Baruch's eye, but in this ca. 1895 photograph, taken while the couple was courting, it's her horse and carriage that impress him.

Bernard Baruch on the porch rail of the Old Relick, as he enjoys the afternoon sun on a winter's day just prior to 1929.

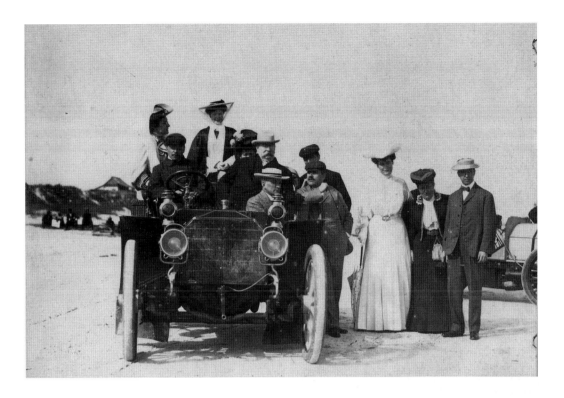

With a distinguished group of friends and cars, Annie and Bernard Baruch (third and fourth from the right) are probably on a beach in Long Island, New York, ca. 1900.

Isabel Wilcox Baruch was born on August 16, 1899, and was the oldest of the three Baruch children.

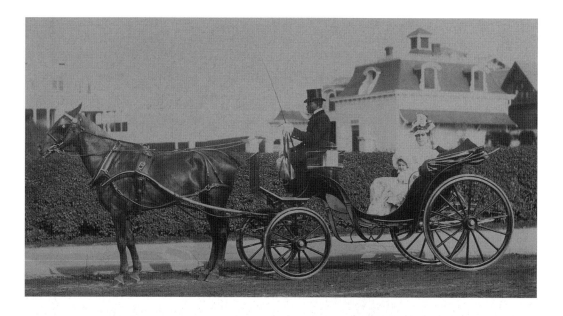

Shortly after young Belle's birth in 1899, Annie and her oldest child are seen in the Baruch carriage at a northeastern resort.

Paternal great-grandmother Sarah Cohen Wolfe rocks baby Belle, ca. 1900, perhaps on the Wolfe porch in Winnsboro, South Carolina. Note the parasol and above-elbow-length gloves worn for sun protection.

Grandfather Baruch, ca. 1905, admires five of his grandchildren seated on the porch with croquet mallets and tennis rackets in Longbranch, New Jersey. Belle is seated far left and Junior is third from the right.

Eight Baruch grandchildren gather on the lawn in New Jersey, ca. 1910, with Dr. Simon Baruch, seated on the grass. *Back right*, Belle Wolfe Baruch; *middle right*, Junior; *far left rear*, Belle; and *second left rear*, Renée.

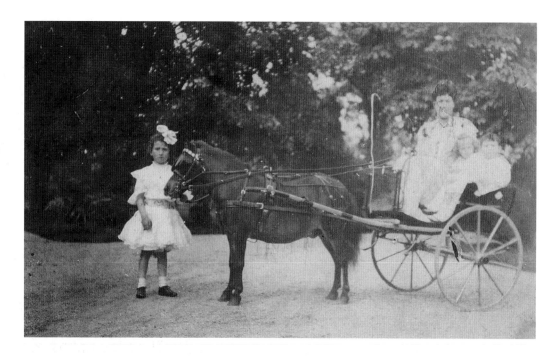

Belle, dressed in fashion, ca. 1905, at the head of her pony cart with her mother, a friend and her brother aboard.

Driving the pony cart with her mother beside her in 1905, Belle was always confident around horses.

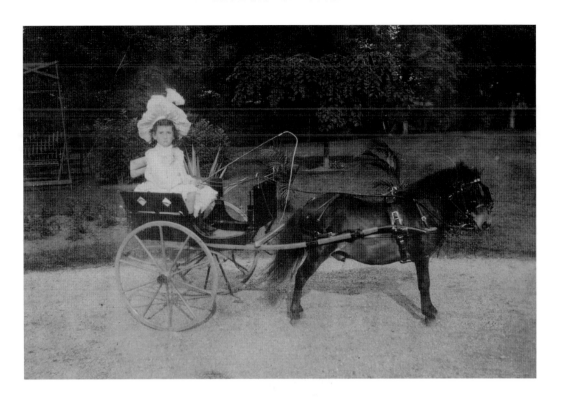

In 1905, Belle with carriage whip was in complete control of her own pony and cart.

Many times preferring the company of dogs over people, Belle enjoyed spending time with a friend in 1907 on the New Jersey coast.

Bernard Baruch, ca. 1919, on the steps of Fetteresso
Castle, Scotland.

Loved by her mother, but the apple of her father's eye,
Belle is pictured in 1903, just before the birth of her
brother, Bernard Mannes Baruch Jr.

Deerhounds outside the Hobcaw House kennels greet Belle and nearly take her gloves, ca. 1908.

Outside their shared dollhouse overlooking Winyah Bay, Belle and her sister Renée ride a hobbyhorse, ca. 1911. Note the two-wheeled, one-seated surrey that served as Junior's goat cart.

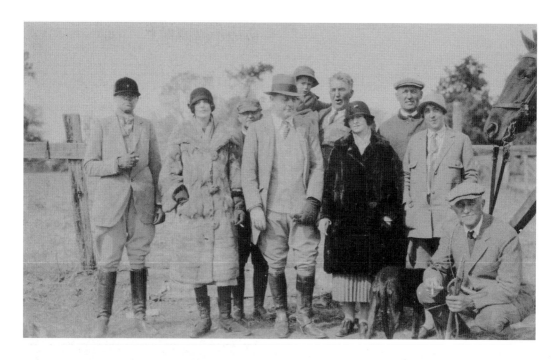

Hobcaw guests, photographed ca. 1920, were entertained well by staff even in the absence of Mr. and Mrs. Baruch. Head superintendent Jim Powell (holding young child) and his niece Lois Massey (far right) kept a book on each guest to describe their favorite hunting guides, horses and drinks.

Junior and Belle Baruch near the Hobcaw dock in 1905, on what is believed to be their first visit to Hobcaw.

Within a few years, Belle Baruch had learned a great deal from plantation manager Jim Powell and felt quite at home at Hobcaw. The two are pictured on the porch of the Old Relick, ca. 1921.

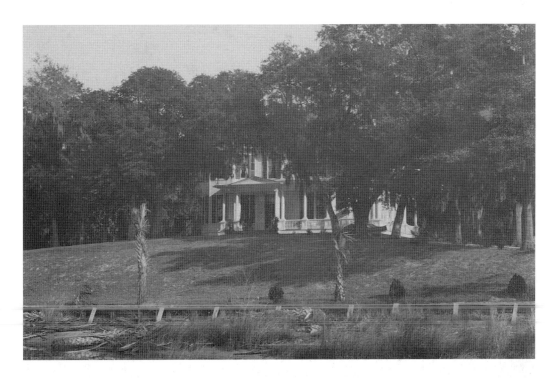

Shortly after their 1905 purchase, the Baruchs added a sun parlor and wraparound porch to the white, wooden main house at Hobcaw.

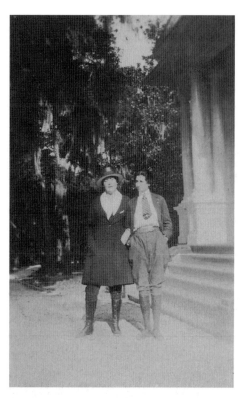

Annie Baruch, ca. 1920, enjoyed being in the country, especially during the years the house was filled with children, nieces, nephews and friends.

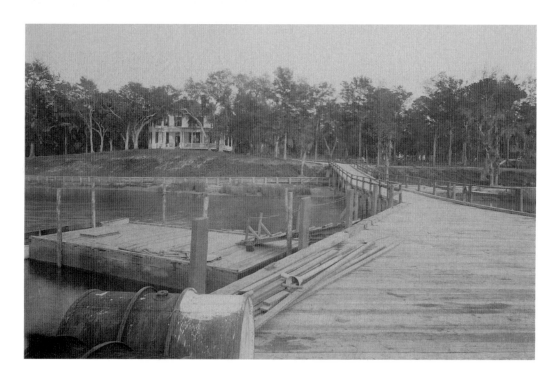

An older, smaller dock built by the Donaldsons was being enlarged about 1905 to accommodate the Baruch yachts and large supply boats.

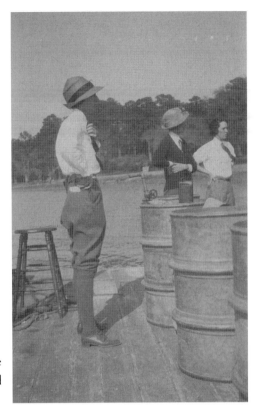

Fuel, both kerosene and diesel, was delivered to the dock in barrels for the generator, which provided electricity to the main house.

'Railbirds,' as labeled in Belle's 1916 photo album, feature Belle (far left); two cousins; and Junior and Renée at the Hobcaw dock.

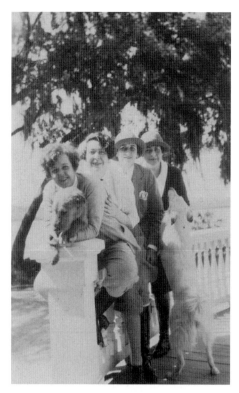

Two pets join Renée, Belle and Annie Baruch and a friend on the wraparound porch, ca. 1926.

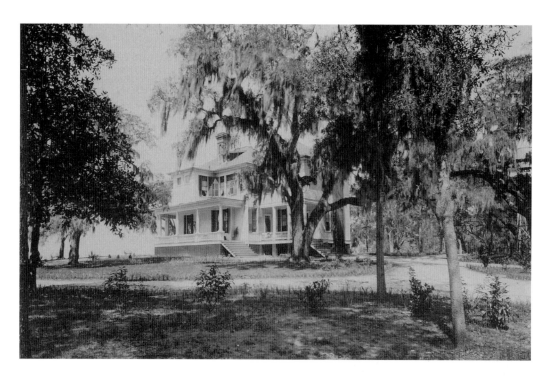

From the southeast, a view of the Old Relick shows how large the house was even before the 1905 purchase and 1907 addition by the Baruch family.

Belle stands beside a collard field at Hobcaw. In 1916, most of the food for families as well as for guests was grown or produced on the plantation.

Belle and Renée wear leather frontier jackets received as presents on Christmas Day, ca. 1918.

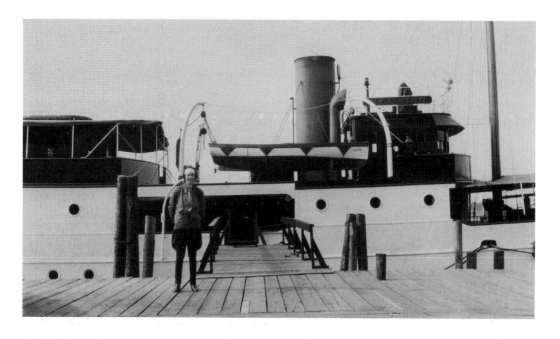

Renée, photographed at the dock in the late 1920s, is welcoming the Baruch yacht, *The Sea King.*

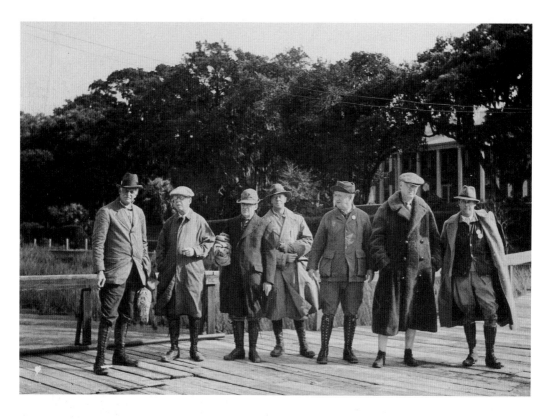

Bernard Baruch and his cronies prepare to board a boat to go up the Black River to hunt quail at Little Hobcaw. This photo was taken sometime after 1931.

In January 1932, the Baruch family welcomed Winston Churchill's yacht at the Hobcaw dock.

John Hancock and Bernard Baruch discuss the hunt in front of glass screens designed to block the wind at the new Hobcaw House, rebuilt in 1931.

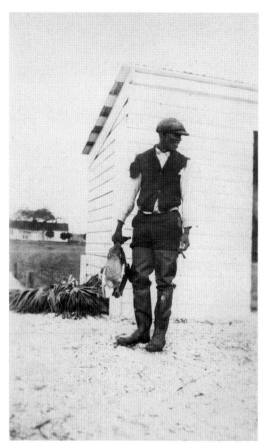

The man pictured at Clambank Landing, ca. 1910, is believed to be skilled hunting guide and boatman George Shubrick, a descendant of Hobcaw slaves.

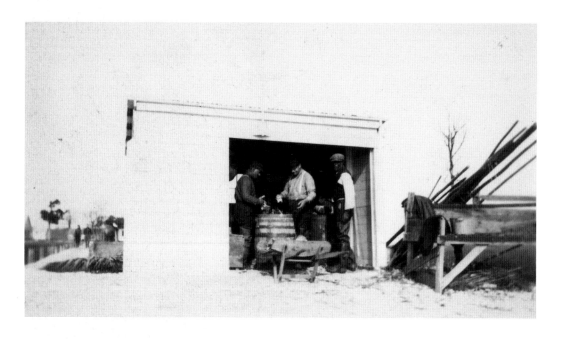

Sawney and Hucks Caines, with George Shubrick, field dress ducks at Clambank Landing, ca. 1910.

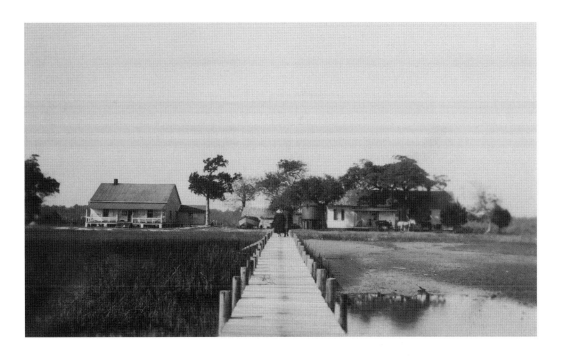

Clambank Landing on Goat Island, seen here ca. 1907, featured both a mid-nineteenth-century and a recently built structure, both used as hunt cabins.

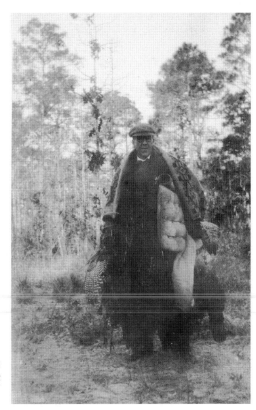

Democratic Senator Joe Robinson of Arkansas was 'the most ardent hunter I ever knew," said Baruch of his friend, photographed at Hobcaw, ca. 1929.

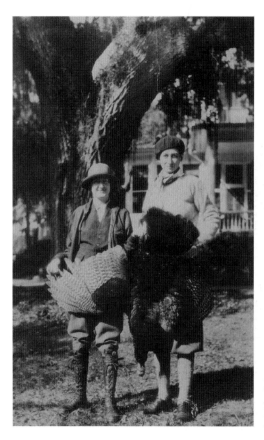

Belle and a friend show off their day's bounty as they pose with turkeys behind the enlarged Old Relick, ca. 1925.

Belle, a cousin, Junior and Renée seated on the mounting block at the main house, midday January 1915.

Baruch's cronies prepare to launch and head upriver for quail hunting at Little Hobcaw, ca. 1931.

The man pictured on this old rice barge, ca. 1910, is believed to be George Shubrick, returning with the Baruch horses and hounds after a fox hunt up the Waccamaw Neck.

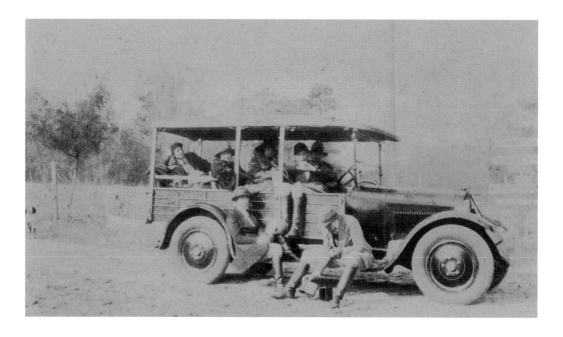

A station wagon and driver stop to read the road signs near Caledonia Plantation on the Waccamaw Neck as Belle (front right passenger seat) and her guests return to Hobcaw after a fox hunt, ca. 1916.

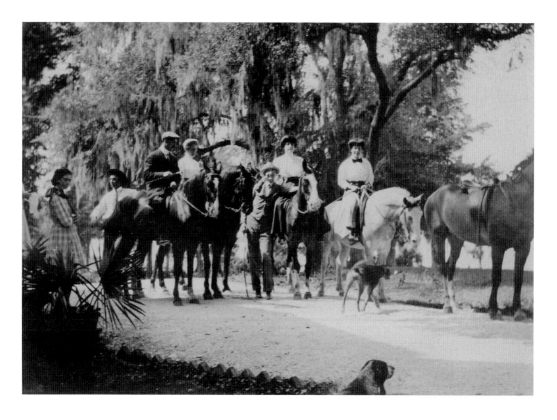

Adults prepare to go afield, ca. 1909, leaving Belle (far left) at Hobcaw House.

Many guests traveled to the woods by horse and wagon for hunting or a midday meal, as did Belle's friend, seen here ca. 1916.

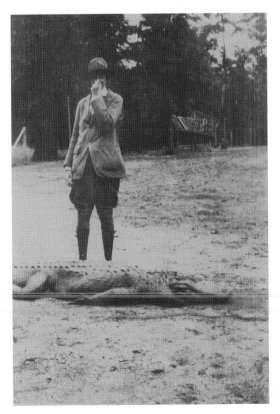

An alligator carcass about twelve feet long begins to smell, according to Belle, ca. 1915.

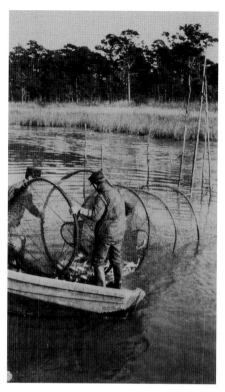

From a handcrafted bateau, Hobcaw staff have good luck with fish traps set in Winyah Bay, ca. 1910.

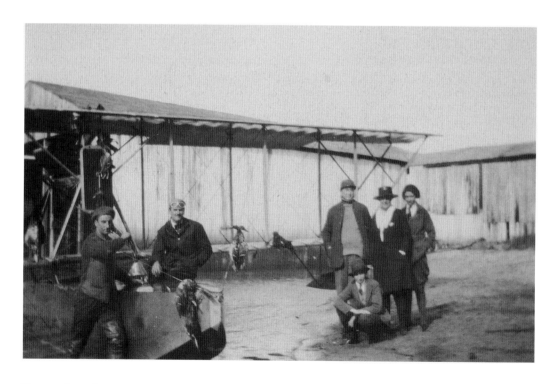

Using a float plane, ca. 1920, a flight technician and pilot (left) give the Baruch family, Bernard, Annie, Renée and Belle, a different perspective on hunting ducks.

"Lucy," either Lucy McCants or Lucinda McCray, was a cook's helper, posed here ca. 1916, with Jim Powell and a group of fishermen who lived on the plantation.

The man harvesting beets from Bellefield Plantation's victory garden, ca. 1942, is believed to be Belle's brother-in-law, Robert Samstag.

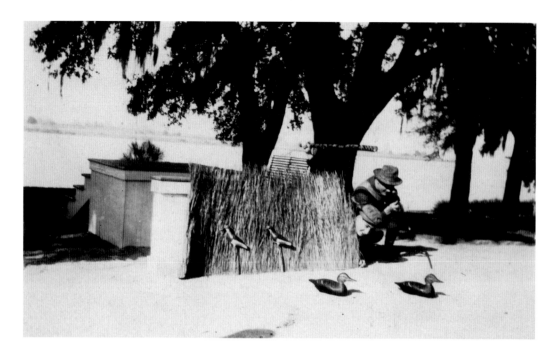

Junior and a cousin clown in the front yard on Christmas Day, ca. 1915, by sneaking up on Caines decoys and tin shorebirds or "tinnies."

Dave McGill (far left), Bernard Baruch, guests and Ely Wilson pose after quail hunting at Little Hobcaw in the 1950s. *Photo by Abe Thomy.*

Belle Baruch, home for Christmas from France, is ready to leave the Hobcaw stables with her mother, ca. 1930.

Dressed for the cold weather are Jim Powell; an employee's daughter (perhaps Olive Buxton); Annie, Bernard and Belle Baruch, ca. 1930. Note Belle's fur-lined boots, mittens and muff.

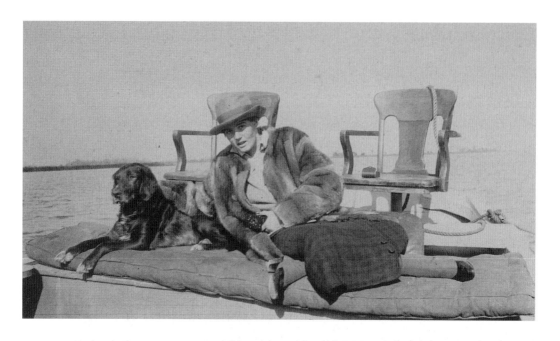

A boat was sent across the bay at least twice a day to pick up mail and messages from Georgetown and some guests and dogs went along for the ride.

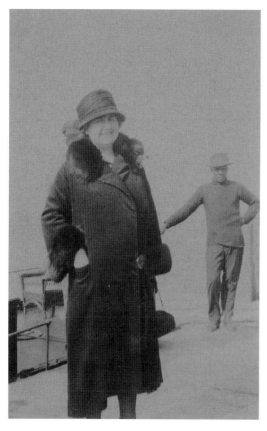

Mrs. Woodrow Wilson disembarks for her first visit to Hobcaw in 1925, as an employee waits to assist.

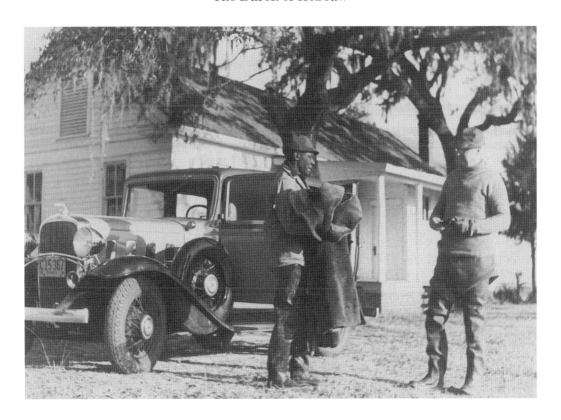

William Kennedy, at Clambank Landing ca. 1936, was Bernard Baruch's right-hand man.

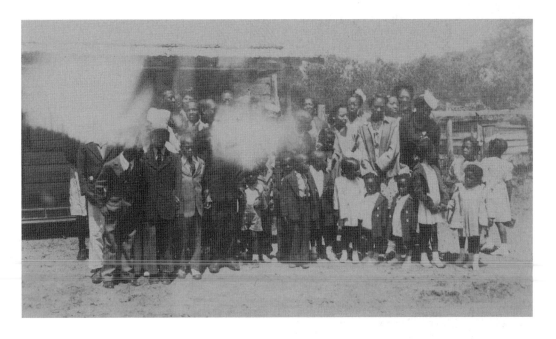

Shown outside a cabin in Friendfield Village, several families are dressed for church on Easter Sunday, ca. 1930.

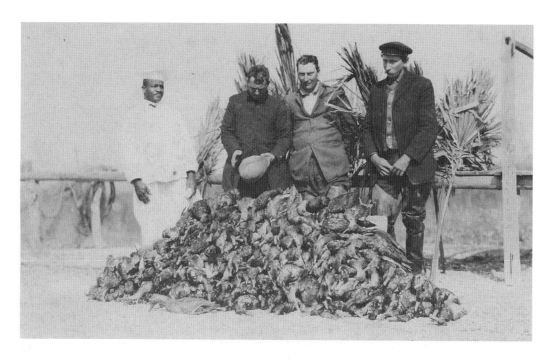

A ca. 1910 postcard features a fair day's hunt at Hobcaw Barony with chef Charlie McCants Sr. and hunting guides Bob, Hucks and Sawney Caines.

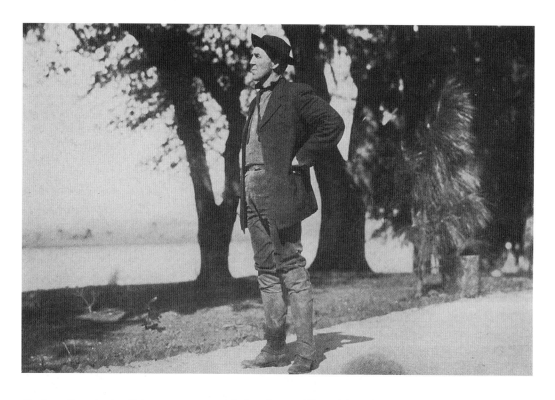

Jim Powell worked at Hobcaw many years before Bernard Baruch bought the barony in 1905.

This lone slave cabin at present-day Oryzantia Plantation was occupied by Rebecca Sands, who is buried in a nearby African American cemetery. *Photo by Jane Allen Nodine.*

Boyd L. Marlow, his uncle Joseph J. Vereen and Captain Howard E. Buxton pose with deerhounds, ca. 1928, at the back of the Vereen house near Bellefield.

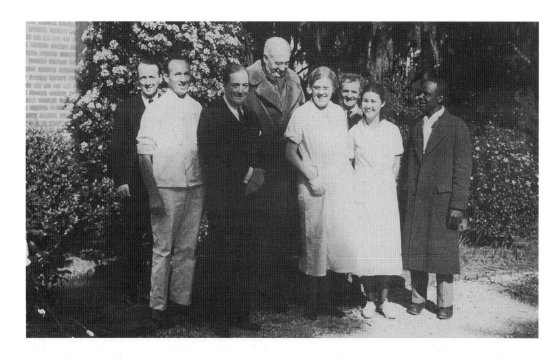

Staff members lived in or near Hobcaw House in the mid 1930s. *From left to right:* Bill Kramer, chauffeur and manager of the kennels; "Jimmy," the cook; Bill Lacey, valet; Bernard Baruch; Lottie Graham, head housekeeper; Josh and Colleen Remish, German butler and maid; and William Kennedy, "jack of all trades."

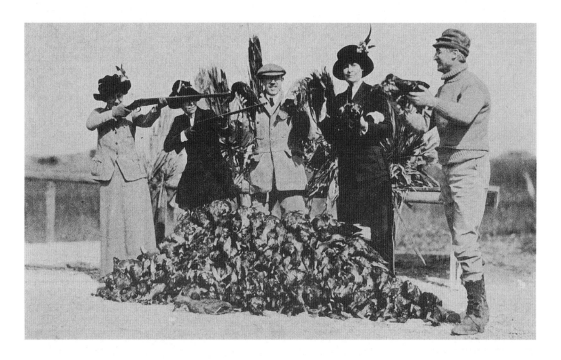

Annie and Bernard Baruch (right) allow guests to take aim one more time as they clown for the camera, ca. 1910.

Belle Baruch checks on students in Strawberry Village one cold morning, ca. 1930.

Many African American employees, photographed here ca. 1925 preparing for a hunt, began to seek jobs off the plantation after a bridge was built to the mainland.

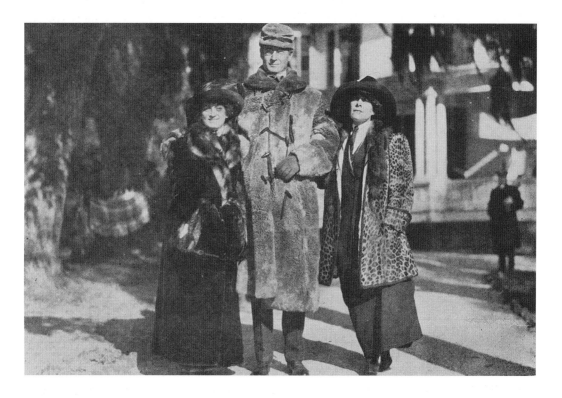

Bernard Baruch and two guests, possibly Baruch sisters-in-law, pose with the baron of Hobcaw for a ca. 1910 postcard.

Fire and Redemption

Christmas 1929 was already a bit unusual. The stock market crash in October had a strong impact on the life of Bernard Baruch, if not from an economic view, then from a social one, as so many others had been affected. Contrary to popular belief, Baruch lost money in the crash, but because he had so much money to begin with, he was not financially ruined, as were so many other Americans.[63] The Old Relick was once again full of family and hunters. By 1929, the three Baruch children were grown, but were still frequent visitors to Hobcaw Barony.

On the evening of December 29, 1929, the white two-story wooden house caught on fire. Guests rushed out the doors and carried what they could save on the way. Wicker furniture, a basket of flowers, chairs and a settee, mattresses and Junior's Victrola from his room seem to be inconsequential items to save. Because heart pine is so flammable, there was no hope of saving the structure. Witnesses later wondered if the family and guests were grabbing seats in order to watch the fire.[64]

Lois Massey was delivering a note from Mrs. Baruch to Mrs. Isaac Emerson at the neighboring Arcadia Plantation, and upon her return, she saw the flames leaping into the sky and reflected in the water of the bay. The group assembled outdoors tried to overcome their sadness and horror with a little humor. At the start of the fire, Senator Key Pittman of Nevada remembered that a keg of whiskey was still in the basement of the house and might, he noted wryly, cause an explosion. He and Supreme Court Justice Richard P. Lydon rushed back in and retrieved the liquor.[65] In an apocryphal account, Lois Massey remembered that when she checked the Victrola, the record saved was "I Didn't Mean to Set the World on Fire," which caused more merriment. The good humor didn't last too long, however. The cold winter evening meant that the guests needed shelter, and most were sent to stay with the Kaminski cousins in Georgetown.

The next day, as the damage was surveyed, Baruch announced that he did not plan to rebuild the house. His family and guests were shocked, but at age fifty-nine, Baruch thought maybe it was time to let it go. Refusing to accept his decision, his guests rose up in arms and told him that he simply had to rebuild and continue the tradition of entertaining

them. However brief his reluctance, Baruch did reconsider and shortly thereafter met with South Carolina architects and contractors from the firm of LaFaye and LaFaye. He first contemplated a house in the Spanish style, not only because it was popular in resorts of the 1920s, but also as a nod to the possible Spanish settlement on the site. The final decision, however, was a Georgian-style house with sixteen bedrooms and fourteen and a half bathrooms. With a total of about thirteen thousand square feet, the Georgian-style house plans included a basement, a full attic with a large cedar closet, and servants' quarters in a rear wing. A major concern, of course, was fire safety, so brick, concrete and steel were the primary building materials; fire hydrants were placed around the exterior; and a pumping system ran under the dock to siphon water from the bay if necessary. While the house was under construction, Baruch moored yachts in the bay, and his guests, not inconvenienced by their makeshift accommodations, hunted and fished as usual.[66]

The newspaper carried accounts of the progress of rebuilding. The materials were shipped by barge, as there were no bridges across Winyah Bay in 1930. The *Georgetown Times* noted that "while Bernard Baruch's great dining room is as yet a mere outline, when completed will once again host luminaries of society. The house, upon completion, will surely be one of the largest mansions on the South Carolina coast, if not the entire east coast."[67]

The new house was opened in the fall of 1931, and within two months, England's Winston Churchill arrived for a visit. He and Baruch had met at the Paris Peace Conference with President Woodrow Wilson and remained close and frequently spoke and corresponded with each other. Churchill called Baruch "my finest American friend."[68] In December of 1931, Churchill was on his way to spend the evening with the Baruchs in their New York City home. He stepped out of his car and into the path of an oncoming car. His severe injuries required hospitalization and a hotel stay, after which he sailed to the Bahamas on his yacht. Upon his return from the islands in January of 1932, Churchill and his daughter Diana stayed several days with the Baruchs at Hobcaw. Belle Baruch and Lois Massey honored Diana's request to ride horses on the barony as the future prime minister continued his recuperation.[69]

Rumors persist, although there is no official documentation to support the claim, that Churchill returned to Hobcaw in April of 1944 when President Franklin D. Roosevelt came for a two-week visit, yet stayed for four weeks during a critical time in World War II. The president's ill health and national security concerns limited the number of places where he could rest, so Bernard Baruch quietly offered Hobcaw Barony as the place where the president, having been advised by his doctors to rest, sleep ten to twelve hours a night and do no more than four hours of work each day, could take his sorely needed vacation. FDR seemed to like the idea, and the Secret Service was dispatched to "sanitize" the area.

Army soldiers from Fort Jackson manned the gate on Highway 17, while marines from Camp Lejeune in North Carolina patrolled the woods on the Waccamaw Neck as well as the woods around the railroad tracks at Graves Station, where the presidential rail car sat in readiness. Naval warships plied the near shore area, the coast guard moved up the five inland rivers and the bay and the Army Air Corps made routine flights over the area during FDR's month-long stay.

The president slept late, sunned, ate well, relaxed and motored up to Bellefield each afternoon for cocktails, which were limited to one and a half per day. His unofficial visit included no speeches, no receptions, no campaigning, yet his "secret visit" was revealed by the ominous presence of various branches of the military. FDR was driven up the Grand Strand past Garden City's target practice range and north to the army's airfield, which later became the Myrtle Beach Air Force Base. On other days, he cruised up the Waccamaw River in Baruch's yacht and caught the eye of many who had heard no word that the president was in town. As the Winyah Bay drawbridge opened to let a yacht pass, motorists got out of their stopped cars to enjoy the spring day. One sixteen-year-old girl caught sight of someone on the deck and rushed to the edge of the bridge to wave to the familiar person. "Hello, Mr. President!" Genevieve "Sister" Peterkin shouted as FDR looked up from the river, lifted his famous fedora and smiled broadly at the young resident of Murrells Inlet.[70]

FDR fished offshore with Ralph Ford of Georgetown, and video footage exists to show staff and guides assisting the president on the water as he vacationed.[71] He was invited to fish a freshwater pond at Arcadia Plantation, just to the north of Hobcaw. Neal Cox, the superintendent for owner George Vanderbilt, remembered showing the president the gardens and then selecting a spot on an embankment at the lower end of the pond where his wheelchair could be positioned easily. With twenty-five security men at Arcadia, FDR caught bream and bass in quick succession. Fala, his little dog, danced and barked with every successful catch. The Secret Service agent in charge of the presidential entourage returned to Arcadia one evening, and Mr. Cox was surprised to find him on the plantation street, sitting on the steps and singing with a member of the black Arcadia Quartet.[72] Before his return to Washington, FDR spoke to the press and commented on the great napping and fishing he had enjoyed while in South Carolina.

The month-long stay at Hobcaw brought Roosevelt the desired rest and reinvigoration. When he died in April of 1945, his doctors and his family felt that the month spent at Hobcaw literally added the year to his life. Baruch was delighted he was able to provide such service to his president and to his country.

As Baruch aged, he remained mentally and physically fit and powerful in business and political circles. In 1946, President Truman named him chairman of the Atomic Energy Commission, and it was in a speech to the South Carolina legislature that Baruch first used the phrase "cold war." The term was repeated by the press, but at some point Baruch revealed that he did not create the phrase, rather his speech writer, Herbert Bayard Swope, did. "Swope coined the phrase; I merely gave it currency."[73]

Baruch's reputation shifted from major player to elder statesman. His previous nickname, "Dr. Facts," earned because of his research on every issue, was replaced by "The Old Man," but he remained the go-to man for the press when they needed a quote. Truman, and even Presidents Kennedy and Johnson in later administrations, were aware of Baruch's clout, courted his support and moreover took his calls.

At age eighty, Baruch was still active, but he realized that he had outlived most of his associates and hunting buddies. Even the wild game was thinning out in the woods of Hobcaw. Federal game laws enacted in 1918, and regularly enforced within a decade,

curbed the "hundred duck days." Baruch found himself at the barony less and less and at Little Hobcaw in Kingstree more frequently. While still enjoying the great outdoors, Baruch found quail hunting more practical and "easier on the bones" than shooting ducks over water during the coldest months of the year.

His oldest daughter Belle exhibited a keen interest in Hobcaw. In response to her requests, Baruch sold her the northernmost 5,000 acres in 1935, and by 1956 had sold all 17,500 acres to Belle, his oldest and his favorite child.

Annie (far left), Bernard (center) and Admiral Cary Grayson, President Wilson's personal physician (far right), prepare to ride with other mounted guests, ca. 1910.

The ruins of the Old Relick lay smoldering after fire destroyed the house on December 29, 1929.

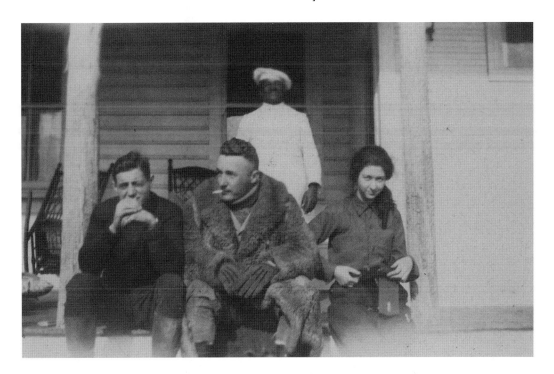

Guests and staff could hardly imagine that Baruch might not rebuild the house, but he began plans to do so in early 1930.

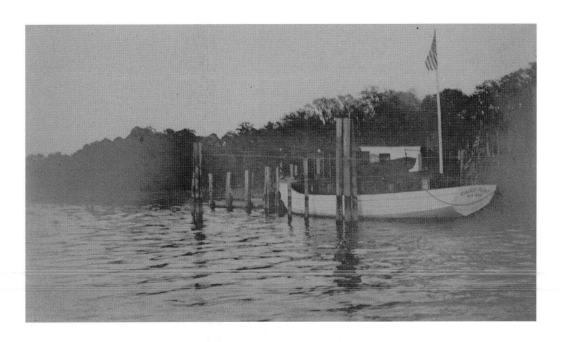

The Eagle Point, the Baruchs' fifty-foot yacht captained by H.E. Buxton, was used to transport guests and then house them after the 1929 fire left all without lodging.

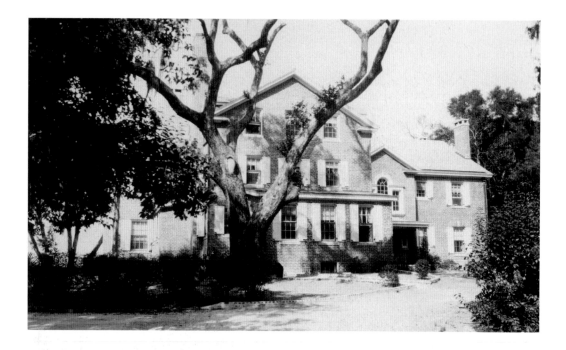

Above the daylight basement, a rear wing contained a kitchen, pantry, servants' dining room, male and female servants' quarters, a pressing room and bathrooms when the house was planned in 1930.

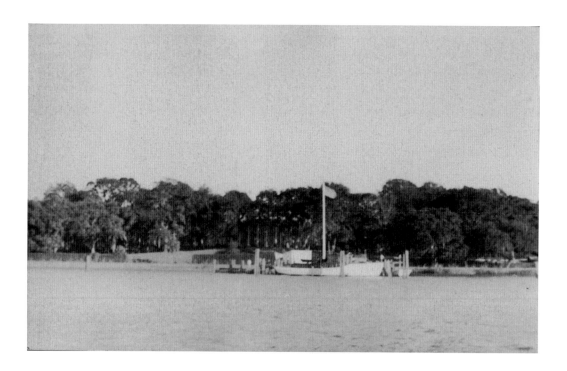

Guests continued to hunt, ride and fish while quartering below deck on board ship while Hobcaw House was being built in 1930-31.

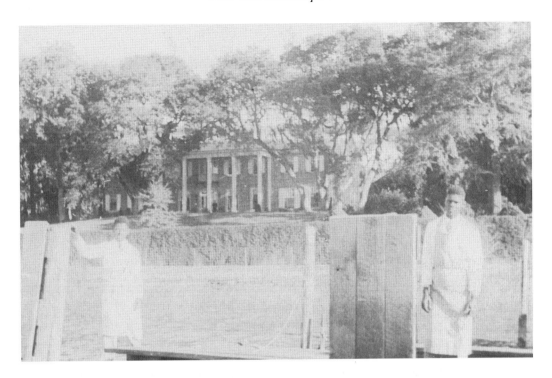

Hobcaw staff, believed to be members of the Fraser and McCray families, stand on the dock in front of the new house, ca. 1931.

Renée Baruch, who would later act as hostess here after the death of her mother in 1938, celebrates the reopening of Hobcaw House in the fall of 1931.

A frail Annie Griffen Baruch seems to be waving goodbye on her last visit to Hobcaw in 1938.

Seen on the dock at Hobcaw in January 1932 are Bernard Baruch, Belle Baruch and Diana Churchill. In 2004, Diana Churchill's daughter, Celia Sandys, visited from England to give a lecture and returned to Hobcaw with a film scout in 2005 to plan a documentary.

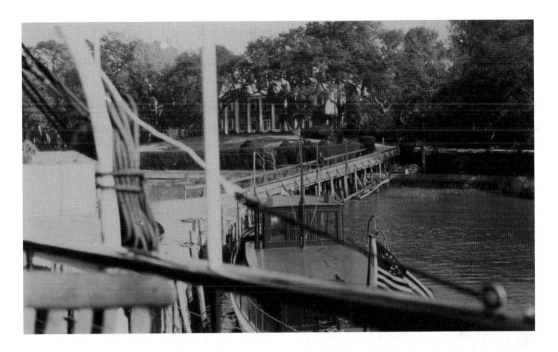

From the deck of the Baruch yacht *Eagle Point*, the smaller launch *Sea Dog* is tied up after its mail run, ca. 1931.

Annie Baruch (right) arrives on the dock at Hobcaw with guests, after having made the boat trip across Winyah Bay in the early 1930s.

In 1944, President Franklin D. Roosevelt sat on the Hobcaw dock under a forty-eight-star flag, while first lady Eleanor Roosevelt learned to crab as the coast guard kept watch for enemy activity.

Baruch remained in the background while at Hobcaw in April of 1944 to let FDR, his staff and the Secret Service have the entire plantation at their disposal.

Employees, such as the man seen here at Clambank Landing, assisted in making FDR's vacation at Hobcaw a memorable one.

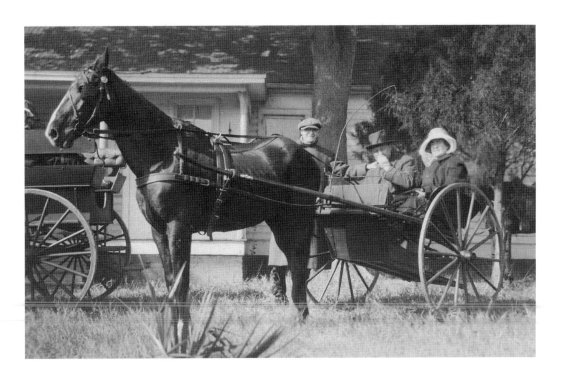

Bernard Baruch assures his guests at Clambank that the six-mile carriage ride back to Hobcaw House wouldn't take as long as the ride out to the marsh.

Bernard Baruch, on the dock with daughter Renée and her husband Robert Samstag in the 1950s, was famous for always wrapping himself up against the cold no matter how warm the Southern sunshine.

From a young age, Belle Baruch, seen here near the Captain's House about 1916, lobbied her parents for a part of Hobcaw she could call her own.

The Friendliest Woods in the World

B elle Baruch was only six years old when her parents bought Hobcaw Barony in 1905. The oldest of three children, she was the apple of her father's eye. Her first spoken word was "Papa."[74] Bernard and Annie Baruch, "Belle," "Junior" and Renée (pronounced Rin-nee) all loved Hobcaw and looked forward to each winter season spent on the Carolina coast. Grandparents Isabelle and Dr. Simon Baruch were part of the family gatherings, as were cousins on the Baruch and Griffen family tree. Belle was named Isabel after her paternal grandmother, although with a slight variation in spelling, and she shared her nickname as well. However, at age twenty-one, the younger Belle had her name legally changed to "Belle" to simply reflect who she felt she was. Family members referred to Bernard's namesake as Junior the rest of his life.

From Thanksgiving to Easter, the children traveled back and forth to the barony with their parents and French and German governesses. The young Baruchs learned to shoot with Captain Jim Powell, ate Lowcountry foods prepared by chef Charlie McCants Sr. and listened to villagers' stories of the plat-eye, hags and haints.[75] Somewhere in between lessons in riding, sailing, oystering, crabbing and hunting, they found time to study music and dance.

The children explored the barony on horseback, buckboard, sulky, carriage or wagon and rode past ruins of plantation houses and rice mills, past cemeteries and military earthen works. They traveled the King's Highway past palmetto swamps, longleaf pine stands, eagle nests and gator crawls. Belle pronounced Hobcaw to be "the friendliest woods in the world."

Belle and Junior competed for their father's attention and recognition of their hunting prowess. Baruch described his son as a natural shot. He loved to tell the story of Jim Powell, "cheek swollen with tobacco and right foot on the dashboard," as he halted the buggy and a short, fat, stubby little replica of Baruch himself at eight years old bounced to the ground and announced he'd brought down eight ducks with his new little gun. Junior's Uncle Hartwig Baruch had given the gun to him with the admonition that it was scarcely big enough to kill bugs.[76]

At age thirteen, Belle made the Georgetown and New York newspapers when she killed a deer, the only one bagged that day among a group of adult male hunters. Invited to join her father's annual deer drive, Belle, with Jim Powell by her side, shot a buck right through the heart. Calling Belle "the youthful Diana," the *New York Herald* reported, "There were forty deer jumped and eighteen shots fired, which resulted in only one deer being brought down and that was killed by Miss Baruch." A few paragraphs below, the newspaper recounted the same day's exploits of Junior: "Bernard Baruch, Jr., who is only nine years old, killed twenty-eight wild ducks today…The boy slipped out to a stand in the marshes all unknown to his family and his father was much pleased when he returned with a bag full of ducks."[77] The sibling rivalry was strong. Belle, however, never killed another deer and as an adult seldom let her guests shoot one. She aggressively prosecuted trespassers and poachers as well.[78]

As a teenager, Belle's athletic ability enabled her to become an expert sailor, winning over fifty sailing trophies by age seventeen. In 1916, her craft, a Bellport Bay-designed yacht, took the Queen of the Bay Championship at Great South Bay, Long Island. Aboard *Miladi*, Belle Baruch was the first female sailor to win this award.

Belle also rode in horse shows from a young age and consistently swept the competition. At the age of twenty-one, she received a trust from her father, as would her siblings, and much to the regret of her parents, she used the money to finance the purchase of a number of horses, soon to be champions in international competitions, and to establish a home at Villa Poeyminau in the horse country of southern France near Pau. She also hired a former competition rider, Monsieur Jean D'Arthez, to manage her stable. His background in veterinary medicine, blacksmithing and handling horses proved invaluable.

In Pau, Belle Baruch joined other American expatriates and the fox hunting set and quickly made a name for herself among the riders. By 1928, she had begun to compete in international equestrian competitions. Onlookers noticed her height—at six feet two inches tall, she was perfectly suited to ride a horse. People also noted that she was a winner. Over the next decade, Belle would accumulate over three hundred awards in international shows, most of which were won astride Souriant III. She won the prestigious Paris Horse Show on April 11, 1931, against 118 competitors and was the only rider to score a perfect performance.[79]

Named Souriant, the French word for smiling, Belle's horse had an excellent disposition and was a phenomenal athlete. Both Belle and Souriant were trained in France by Paul Larregain, who had first taken notice of Belle in the fox hunting fields. His training, her sense of timing and the physical best of both horse and rider made Belle the talk of the horse set, for she was usually the only American and often the only woman competing in shows in France, Italy and Germany.[80]

At the end of each horse show season, Belle returned to Hobcaw Barony for the family's annual Christmas gathering to hunt, fish, ride and renew her spirit. The rebuilding of Hobcaw House had been completed while Belle was in Europe. While holding fewer memories for her, the new brick home was on the land she loved.

The Baruchs encouraged Belle to return to America in the 1930s. When the political climate in Europe became dangerous for Americans, the situation was especially perilous

for a woman whose surname was Jewish. Belle's high-profile equestrian victories in Germany and Italy led representatives of both Hitler and Mussolini to request the purchase of her renowned Souriant III. Her blunt refusals, peppered with sarcasm, only promoted her notoriety.

With the inevitability of war in Europe, Belle considered returning to America, and in the early 1930s, she pressed her father to sell her part of the barony. She waited several years for him to make his decision, but at Christmas in 1935, Baruch announced that he would sell the northern half of Hobcaw to Belle. As much to avert sibling rivalry as to save on taxes, Baruch decided to sell the land to his older daughter rather than make it a gift. Belle bought six plantations, Alderly, Oryzantia, Crab Hall, Youngville, Bellefield and Marietta, and chose to call her holdings Bellefield.

In January of 1936, Belle hired architects Murgatroyd and Ogden of New York and contractors LaFaye and LaFaye in Columbia, South Carolina, to construct a white wooden country home, which also incorporated recycled nineteenth-century Charleston bricks. This house rose to take its place beneath live oaks and magnolias. While adding camellias, azaleas, rye grass, a patio, a pool and brick-lined pathways, Belle kept the integrity of the woodland setting. Her large sunroom, like the sun parlor in the Old Relick, faced south and overlooked the rice millpond that she enlarged and stocked with fish. Smaller and less imposing than Hobcaw House, her estate reflected her subdued style of entertaining.

Belle hired her own staff from the villages at Hobcaw. William and Daisy Kennedy moved from the back gate of Hobcaw House to be nearer to Bellefield. Elvira "Mocking" Palmer walked each day from Friendfield, while Joshua and Diana Jenkins walked from Barnyard Village. Numerous others found work at Bellefield in later years as well. Francena and Charlie McCants and Prince and Rosa Jenkins worked for Belle, and after the deaths of their respective spouses, both Francena and Prince continued to commute to Bellefield from their homes in Georgetown until the late 1990s.

Belle moved her French groom and stable manager Jean D'Arthez and his family to Bellefield and built a cottage for them, which overlooked the paddock. While still in France, Belle received updates from Jim Powell and his niece Lois Massey as they communicated construction progress from Hobcaw. They continued to serve as mentors and staff for many years. Another mentor and lifelong friend was Mrs. Woodrow Wilson, who was an early and frequent visitor to Bellefield. Edith Bolling Wilson also became a surrogate mother to Belle after Annie Baruch died unexpectedly of pneumonia in 1938.

Within ten years, Belle hired Nolan Taylor of Beaufort, North Carolina, as superintendent and together they met the challenge given by Bernard Baruch to manage the entire barony. Under Belle's direction, Taylor maintained the roads, seeded the oyster beds, worked out agreements for the boundaries of dredge spoil deposit sites, killed nuisance wild pigs and patrolled for poachers. He also maintained the airport runway, which Belle added to Bellefield after 1945.[81]

Belle had traded the thrill of competitive riding for the exhilaration of flying. Becoming a pilot at age forty, she had a license for a single-engine and a twin-engine plane. Her staff pilots were Ken Unger, Clayton Kinney and Kenny Heflin. Initially, she kept the planes in a

hangar in Georgetown, until after World War II. About 1947, Belle dismantled and placed the hangar on Bellefield land and created a fifteen-hundred-foot runway. Having access to a plane made frequent travel from her apartment in New York to Hobcaw much easier and allowed her to enjoy more numerous short stays.

Belle was three years old when the Wright Brothers made their first flights, and through the years she heard of records being set and speeds being broken. Most of all, she was fascinated by the female pilots of the era who braved the skies. A daredevil at heart, Belle delighted in surveying for poachers and trespassers from her cockpit. Georgetown residents and former staff members recount stories of Belle and her plane appearing from nowhere to "buzz" someone who was hunting from a boat in her rice fields. She learned just how low to fly to avoid "tumping them over" and destroying evidence of their duck or deer poaching. More often than not, Belle and the sheriff were waiting for the hapless lawbreakers upon their return to Georgetown.

In the 1940s, World War II touched the lives of many people who were associated with Hobcaw Barony. Bernard Baruch was in Washington encouraging war preparation and meeting with military officials, members of Congress and economic leaders. Sons of employees, both black and white, enlisted in the service, and daughters, often with the help of Bernard Baruch, found jobs as factory workers or secretaries. Minnie Kennedy worked as a shipfitter in the Brooklyn Navy Yard. Lucille DeLavigne, daughter of Superintendent Joe Vereen, recalled boarding a train in 1943 with an envelope in her hand. Scribbled on the back were a name, address and the words, "Give this girl a job—BMB."[82] At Bellefield, the women gathered rolled bandages and knit sweaters. Gas rationing and blackouts were observed and victory gardening provided food for the table. Belle's planes were confiscated by the Army Air Corps, and her hangar was commandeered between May and September of 1942 as a base for field operations.

Approximately three hundred U.S. Coast Guardsmen were part of the Mounted Beach Patrol, which stretched from North Myrtle Beach to Cape Romain. Some were stationed at Magnolia Beach (now Litchfield), Pawleys Island and North and South Islands. With the purpose of protecting the coast from invasion by German U-boats, the patrol was formed after German subs began attacking allied merchant ships. The U-boats also ferried spies and saboteurs across the Atlantic.

Naval Intelligence and the coast guard joined forces to protect the coast, and J. Edgar Hoover involved the FBI in the cause as well. Belle was asked to work for Naval Intelligence in 1942; her job was to observe the five-thousand-acre marsh and the two miles of beachfront that she owned. There, on the southern end of DeBordieu Island at her Grass Shack, where she had enjoyed swimming, fishing, picnicking and camping, the war had put all on high alert. Belle's records from 1942 show that one night she observed flashes of lights, explosions far out at sea and a shadow on the beach. The next day the coast guard reported that a German sub had been spotted off the coast. That afternoon, Belle found and turned in a ship's rudder, flares, canvas covering and boards marked "Navy Yard, NY." Another night while she was on patrol, a man appeared on the beach, saw Belle and ran through the dunes. The coast guard later told her that he was not one of their men.

During World War I, Belle had served as a trained telegrapher in the Women's Radio Corps, so she was able to recognize the flashes of lights that she observed in the summer of 1942 as Morse code, and she made accurate reports to Naval Intelligence. Sightings of footprints and vehicle tracks also appeared in her reports, and on one occasion a dual-engine plane flew low over the beach toward Georgetown. As she headed off to make a report, she encountered two armed men who asked for directions to town. Upon returning to the spot with Georgetown police, Belle observed the men's footprints leading to the water. Once, a dory was beached on DeBordieu, and three men were spotted off shore in a rowboat. As the boat headed toward shore, two of the men climbed aboard the dory. Lacking a two-way radio, once again Belle had to leave the site to summon police and once again they returned to a deserted beach.

The most dramatic moment for Belle as a coastal observer occurred on a fall night in 1942 when she was on mounted patrol. She and Lois Massey saw a man come ashore in a small rubber boat. He hid the boat and headed for the highway. While Lois continued to watch him, Belle urged her horse through the dark to Bellefield, where she transferred to her car. Once alerted, the police caught the man as he headed to Pawleys Island. Appearing to be a German agent from a U-boat, the mysterious stranger was turned over to the FBI. Belle never received details of the incident, only a letter from J. Edgar Hoover thanking her for work that led to an arrest.

By October 1942, the coast guard announced that they had recruited and trained enough men to take over night patrols. In February of 1943, Belle was summoned by Hoover to meet in Washington, but she never revealed the nature of their talks. Few who knew Belle or who lived in the area were ever aware of the enemy activity that had taken place along the coast during the war years.[83]

Belle Baruch's devotion to duty was matched by her philanthropy. A strong supporter and often an anonymous donor to charities, she visited numerous medical centers in the United States and abroad. She met doctors and therapists involved in physical therapy and supported their research. Active in charities for the blind and for the victims of polio, Belle established a scholarship at New York University in physical education and rehabilitation. As her employees aged or became ill, she often provided transportation by car or plane for treatment.

In late 1962, Belle Baruch herself fell ill. Complaining of abdominal pains, Belle went to doctors in New York who recommended exploratory surgery. They discovered cancer, but at the request of friends closest to her, the doctors did not reveal their diagnosis to Belle, nor to her ninety-two-year-old father. After her hospitalization, Belle returned to Bellefield's nurturing woods, where she rediscovered hog hunting. Feeling fine, she headed out in her jeep with Nolan Taylor to kill the wild hogs that continued to threaten the native wildlife and plants. That same spring, Belle discovered an abandoned fawn and raised it as a pet. Staff members remember that Deary-Deer had the run of the house and grounds. His simple antics brought pleasure to Belle and to those around her.

Belle continued to fly and considered buying a new plane as she traveled to New York in 1964 for a follow-up visit to her doctor. Her vision and speech were causing difficulties and

the doctors quietly discovered that the cancer had returned. Again the news was withheld from both father and daughter, as it had been two years before this surgery. Bernard Baruch and Belle used a visit at the hospital to discuss her idea of purchasing a new plane. He argued with her that it was an unnecessary extravagance, but as a trained pilot, Belle was eager to upgrade. When the conversation became heated, Baruch was pulled aside by his personal nurse, a close family friend. She delicately told him that Belle was dying and suggested that he let her buy her new plane. The news was overwhelming.

Baruch returned to Belle and told her that he had reconsidered, that she should get that plane if she really wanted it. She smiled and said she had changed her mind.

Belle Baruch, here almost two years old, prepares to take her hobbyhorse on a ride in the country. The studio shot, taken ca. 1901, foreshadows her lifelong love of horses.

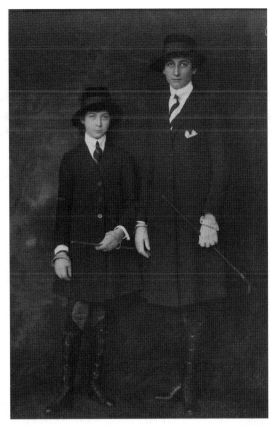

Renée and Belle Baruch pose in riding habits, ca. 1913.

A former governess returns to Hobcaw and is taken for a ride around Bellefield, shortly after its construction in 1936.

Belle, Junior, Jim Powell and a cousin shoot skeet on the front lawn during the same season Belle brought down her first deer, 1913.

Renée Baruch walks her dog near the new seawall, which is marked "Mr. J.R. Powell, Nesbit, Capers - May, 1913."

Little Renée, born in 1905, seems confident astride a very tall horse in the backyard of the Old Relick.

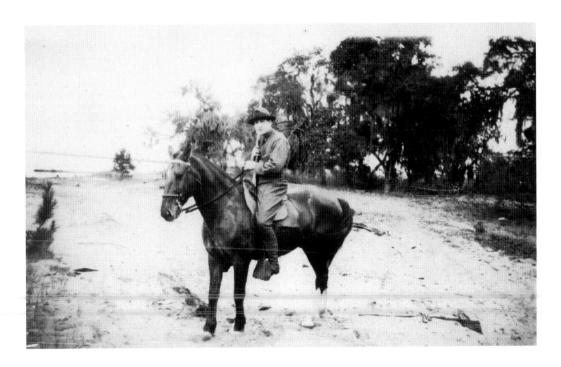

Junior, born in 1903, sits in an old army saddle as he does some hunting on the western shore of Hobcaw, ca. 1919.

Hobcaw House appears through the trees in this ca. 1935 postcard.

Junior and his father, ca. 1919, on the crushed-shell path at Hobcaw House.

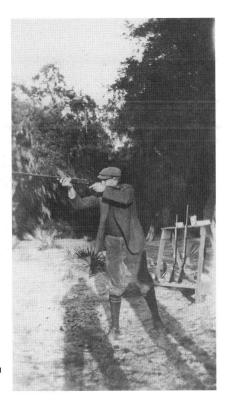

Jim Powell, seen here ca. 1913, was a brave man and an excellent marksman. His nickname was "Sadie."

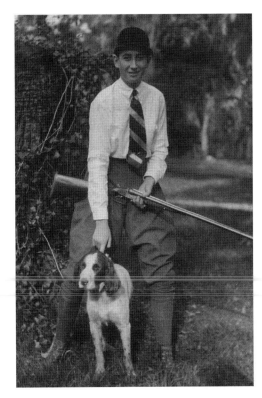

Belle, at age thirteen, brought down her first deer on New Year's Day 1913, and made the New York and Georgetown papers.

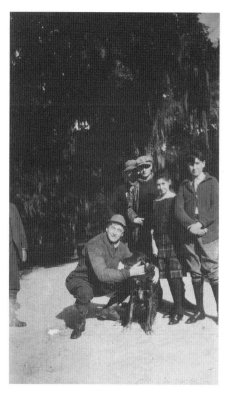

In this 1915 photo, two cousins, Renée and Junior join Baruch, who was proud his retreat brought the family so much pleasure.

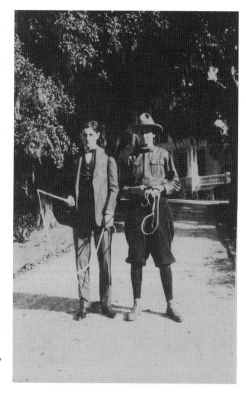

A cousin and Belle learn to crack a whip while at Hobcaw in the winter of 1915.

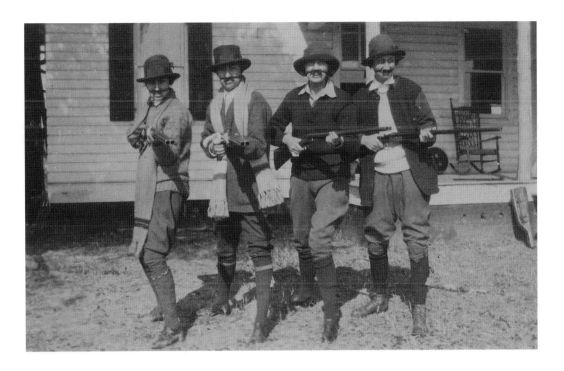

Belle Baruch and her silly friends find a new way to ward off poachers at Clambank, ca. 1916.

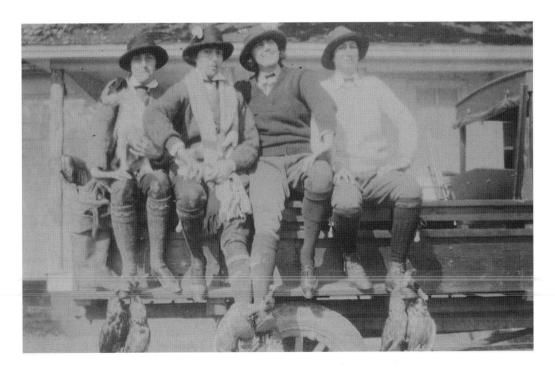

Back on the truck, the girls replace their moustaches with smiles, pleased with the ducks they have bagged.

Aboard *Miladi*, her Bellport Bay one-design yacht, Belle and Langdon Post navigate Great South Bay, Long Island, New York, in 1916.

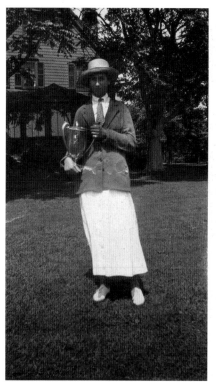

At age seventeen, Belle was the first woman to win the coveted Queen of the Bay Cup, one of nearly two hundred sailing trophies she was awarded.

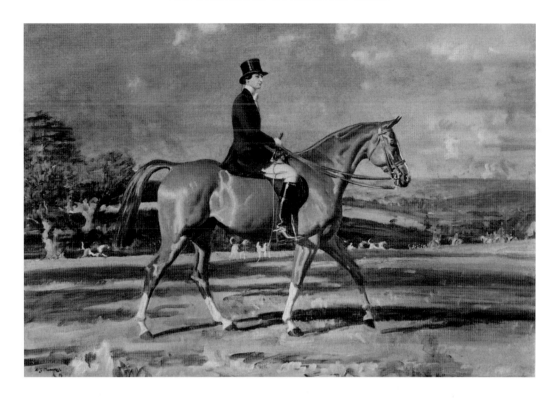

In a ca. 1935 portrait painted by Sir Alfred Munnings, Belle and Souriant III are depicted fox hunting in the Pyrenees Mountains between France and Spain.

This early postcard shows Baruch's guests ready to set out on a fox hunt. Decades later, Belle and her guests also enjoyed moonlight fox hunts at Hobcaw and up the Waccamaw Neck.

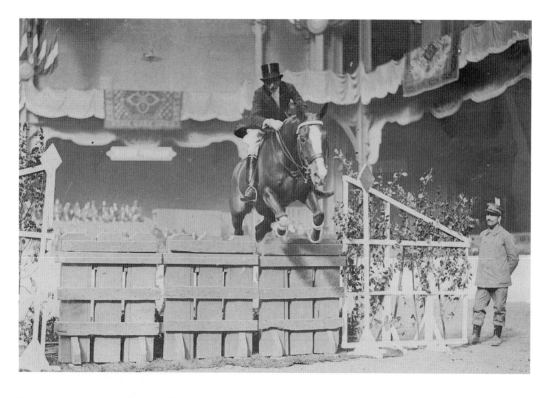

Belle's victory astride Souriant III at the Paris Horse Show in 1931 was record-breaking.

Renée Baruch, shown here at Arcadia Plantation, ca. 1920, was as well known for tennis as Belle was for sailing.

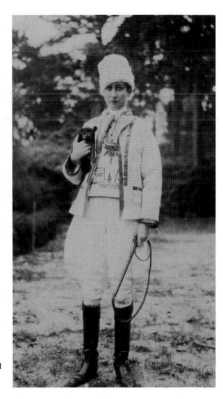

Home from Europe for Christmas in the 1920s, Belle strikes a
pose in an unusual costume.

Dave McGill, superintendent; Bernrd Baruch; three guests and Ely Wilson, hunting guide, prepare for a
quail hunt at Little Hobcaw near Kingstree, South Carolina, in 1953.

Either as a stunt or as a result of arthritis caused by horse riding, Belle gets a wheelchair push from her mother, ca. 1938. Note the monogrammed horse blanket.

After sailing on the SS *Normandie* from France to New York in 1937, Belle, Varvara Hasselbalch and Barbara Donohue boarded a train to South Carolina, then went by boat once more to cross the bay to Hobcaw.

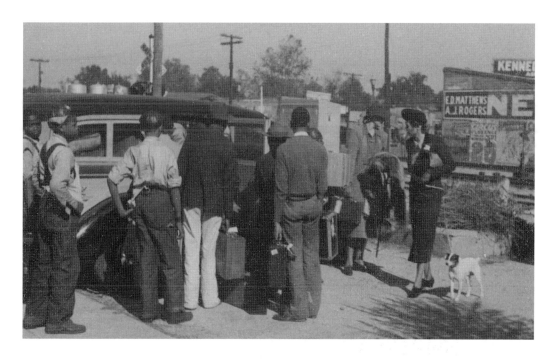

At the Kingstree train station, Belle and Varvara Hasselbalch are met in the early 1930s by the Hobcaw car and a retinue of staff and onlookers.

Souriant III was trained by Paul Larregain and competed at Mottravonna, Italy, in 1931.

Renée, Bernard and Belle Baruch begin a ride from Bellefield stables, ca. 1950.

Marie Glinn, Lois Massey and Barbara Donohue join Belle for a picnic at Hobcaw in 1938.

On one of her many visits, Mrs. Woodrow Wilson surveys
Belle's new home, built in 1936 at Bellefield.

Belle's former German tutor, Fraulein Bleumenthal, returns not as an employee, but as a guest and is
treated to a surrey ride from the new owner of Bellefield in 1936.

Belle, a male friend and Barbara Donohue share a picnic at the Carolina Cup races in Camden, South Carolina, in 1938.

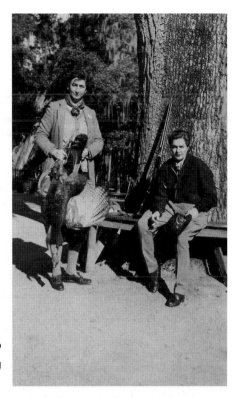

During World War II, Dickie Leyland came from England to live at Bellefield, and she and Belle hunted turkeys during the holidays in 1943.

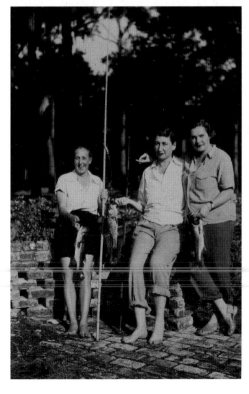

Lois Massey with a cane pole, and Belle and Dickie Leyland with a rod and reel, fish in the Bellefield pond, ca. 1943.

Between 1936 and 1938, Annie Baruch went clamming at North Inlet with Belle. Note the two important tools she carries: a clam rake and a Charleston rice spoon.

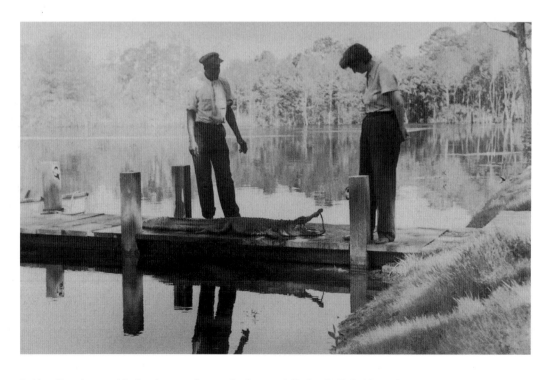

Bobbie Hamilton and Belle observe the small alligator killed at Bellefield pond, ca. 1945.

Belle, Jean D'Arthez and Lois Massey break the ice on the stables' water buckets on a cold day in the early 1940s.

Barbara Donohue helps train Keepsake, or 'Kiki,' as a carriage horse shortly after 1937 when the Bellefield stables were completed.

Mrs. Woodrow Wilson loved to ride at Hobcaw and did so on her first visit in 1925.

Mrs. Woodrow Wilson went crabbing in North Inlet using a handline and found success, ca. 1936.

In 1938, Annie Baruch contracted pneumonia while at Hobcaw but delayed returning to New York to see her own doctors. The delay proved to be a mistake, for Annie died within a few days.

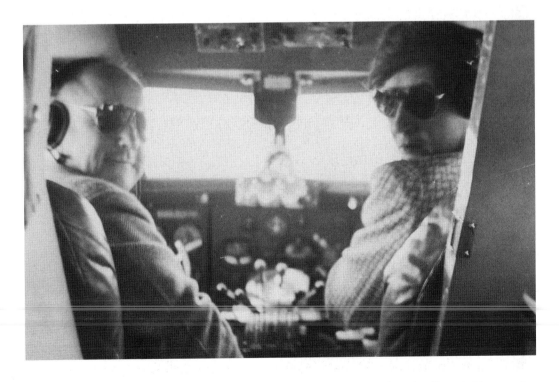

Ken Unger and Belle, in the cockpit of her twin-engine plane, prepare for takeoff, probably just after World War II.

Belle's single-engine Stinson was housed in a hangar that she bought from the half-brother of Doris Duke and which she kept in Georgetown until 1947.

The U.S. Army confiscated Belle Baruch's airport hangar, located in Georgetown, during World War II. Driving to Georgetown in Belle's 1947 Buick, she and Varvara Hasselbalch made plans to move the hangar to Bellefield on Hobcaw.

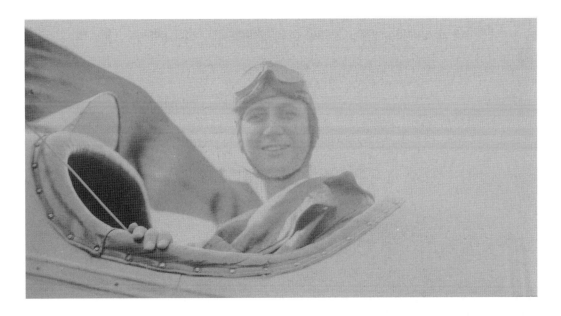

From the time of her first flight with friend and pilot Evangeline Johnson, ca. 1916, Belle was thrilled with aviation.

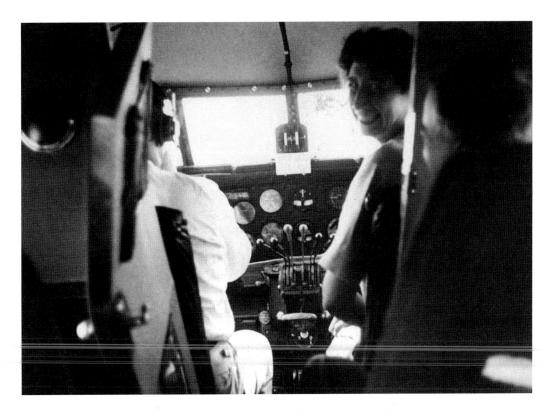

Staff pilot Ken Unger and Belle Baruch are in the cockpit of her twin-engine plane on a flight from New York to South Carolina, ca. 1947.

Ken Unger and Belle Baruch return from a flight over Hobcaw, one of many she made in order to patrol for poachers who were illegally hunting and fishing on her property.

Belle sought privacy and warm sun on DeBordieu Island with staff member Lois Massey and friends, ca. 1941.

During World War II, Belle used her Grass Shack as a lookout post for her work as a coastal observer.

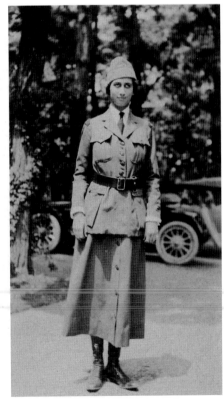

While Belle was serving in the Women's Radio Corps in World War I, she learned and taught Morse code communication.

Abandoned vehicles were always cause for concern during World War II, and there were many unusual activities and suspicious persons reported during Belle's watch in 1943–44.

Belle returned to flying after the war, but she never revealed her correspondence and conversations, deemed top-secret by the FBI, with J. Edgar Hoover.

Stomach problems began bothering Belle about 1960. Her friends encouraged her to see New York doctors, but she resented the time spent away from Bellefield.

Belle killed feral hogs long after she had ceased hunting wild game at Hobcaw Barony.

By 1962, Belle Baruch knew her health was compromised, and she made plans for the future of Hobcaw Barony.

A Plan for Preservation

As Belle grew older, she worried about the future of Hobcaw Barony, especially since there were no obvious heirs to the land. She had never married nor ever had children. Her brother Junior had married several times, but he had no children. Her sister Renée had a lifelong, happy marriage, but she, too, had no children. Most of all, Belle's strongest desire was that the property remain undeveloped. She longed for Hobcaw Barony to revert to the natural woods and waters that had provided habitats for the diversity of wildlife she had encountered and so enjoyed in her childhood.

Conservation in the 1960s was primarily a function practiced by the state and federal governments, and although hunting regulations were being enforced locally and nationally, large tracts of land were rarely set aside by individuals. Belle feared that making a gift of the land to the state might mean subdivision or a lack of commitment to her goals for the property. She and her close friend and companion of many years, Ella Severin, met with attorneys and devised a plan that ensured protection of Hobcaw Barony for the future. Belle created a trust to finance the plantation's preservation, and also offered a life estate to her sister. Renée could use Hobcaw House and its surrounding acreage throughout her lifetime. Renée had greatly enjoyed her time at Hobcaw, and she had served as her father's hostess after the death of her mother. She was also pleased that Belle had been able to purchase the entire barony. Renée and her husband, Robert Samstag, owned their own country estate near New York City in Pound Ridge, New York, and she assured Belle that preserving the land as a park or center for conservation was a wise idea.

Junior visited Hobcaw less and less after World War II, and many people close to the family presume that he missed the days when great crowds of important people hunted and socialized at the shooting preserve. He may even have been disappointed that his father had sold the land to Belle. Whatever the reason, brother and sister became estranged, and, although he rarely visited, he made thoughtful gestures from time to time, which Belle appreciated. However, Junior was not included in any future plans for the property.

Belle did offer a life estate at Bellefield to Ella Severin, who had resided there with Belle since 1951. With a background in business, Ella helped Belle and her attorneys formulate details on how the land could be used yet still support itself as undeveloped property.

Belle's health worsened, and as she entered Bellevue Hospital in New York, Ella, Renée and Mr. Baruch kept a vigil. The cancer had spread to her brain and within a few days, she was in a coma and died quietly on April 24, 1964, at the age of sixty-four.

Belle had hoped to be buried at her beloved Hobcaw Barony, but her ninety-three-year-old father insisted that she be laid to rest beside her mother and grandparents in New York at Flushing Meadows Cemetery. Shortly after her funeral, when the provisions of her will were announced, Hobcaw Barony was officially designated "for the purposes of teaching and/or research in forestry, marine biology and the care and propagation of wildlife and flora and fauna in South Carolina in connection with colleges and/or universities in the state of South Carolina." Her creation of a trust allowed board members to form a foundation that Belle had named in honor of her father. Bernard Baruch survived Belle, however, and wanted the organization to carry her name and reflect her goals for the plantation's future. The trustees acquiesced and all the arrangements were in place by the time of Bernard Baruch's death on Father's Day, 1965.

From her first glimpse of a Carolina sunrise over a marsh, an eagle on its nest at the edge of a rice field and a silhouetted cypress reflected in moonlit waters, Belle Baruch knew Hobcaw Barony was special land that deserved preservation for future generations.

The numbers of ducks declined dramatically in the 1930s, as observed by William Kennedy and Belle Baruch after a hunt near Clambank Landing.

Belle and Lois Massey start a fire to boil water, probably for crabs or oysters to be enjoyed at a picnic, ca. 1940.

Annie and her daughter Belle prepare to go crabbing in North Inlet between 1936 and 1938.

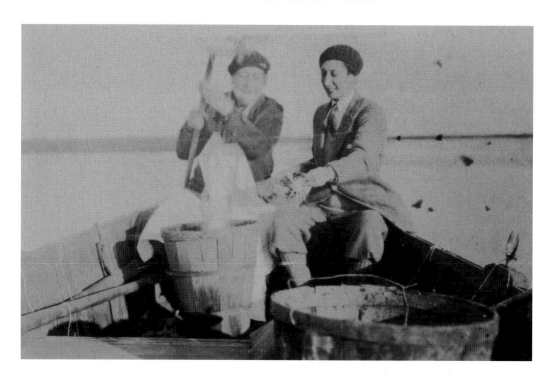

The crabs cause excitement as Annie Baruch lowers them into a bushel basket.

Belle Baruch always had a strong love of the land, not just a love of house parties and social events, so her thoughts were on its future long before she grew old.

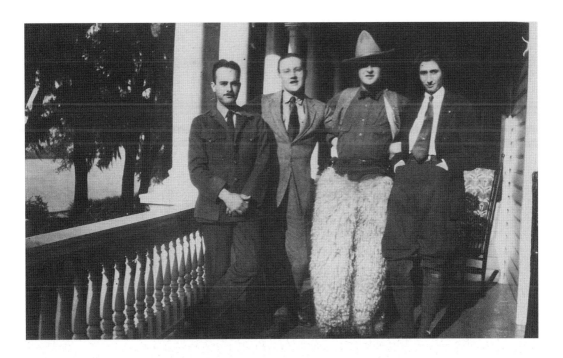

As an adult in the 1920s, Belle asked repeatedly to purchase her own part of the barony and was eventually sucessful.

Belle's companion between 1951 and 1964, Ella Severin, had a business background and, until her death in 2000, guided the foundation with a strong and sensitive hand.

Annie and Bernard Baruch reestablished the barony in 1905 and shared their retreat with others. Their daughter Belle sought to create a place dedicated to the pleasures of nature, not to the exploits of man.

9.
Belle's Legacy

Since 1964, the Belle W. Baruch Foundation has owned and operated Hobcaw Barony as a center for education and research. Belle's will designated a plan to protect the unique natural resources of the land while having the property serve a useful purpose for the people of South Carolina. She bequeathed funds for the land's maintenance and named trustees to serve the foundation. With great love and foresight for Hobcaw Barony, she enabled generations of people to understand and to learn from Hobcaw's forest, marsh, swamp and beach.

Hobcaw Barony is part of the largest piece of protected property on the east coast of the United States. Between Georgetown and Charleston lie sixty miles of shoreline that is operated either by private, state or federal organizations for conservation. Hobcaw Barony, Yawkey Wildlife Center, Santee Coastal Reserve, Cape Romain National Wildlife Refuge and Capers Island all offer some form of public access.

As pressures grow from a population shift to the South Carolina coast, the words of Ella Severin, long-serving resident trustee, are proving to be prophetic: "Mark my words. Some day Hobcaw Barony and Brookgreen will be like two oases in a sea of development."[84]

In 1968, Clemson University's Belle W. Baruch Institute of Coastal Ecology and Forest Science began conducting research and education programs on the South Carolina coast. The institute provides scientific expertise in forestry and natural resources. Clemson's goal is to address issues important to coastal businesses, homeowners, communities and government agencies.

From its inception, the institute has partnered with the Baruch Foundation to build relationships with the South Carolina Forestry Commission, U.S. Fish and Wildlife Service and the International Paper and MeadWestvaco companies. The institute has been instrumental in helping coastal communities prosper by preserving natural resources. Clemson researchers have been involved in projects concerning the best management practices for forestry, analysis of pollutants that flow through the water table and the impacts of hurricanes on the environment.

Also of benefit has been research that leads to and aids in the stabilization of riverbanks and waterways, the establishment of wildlife management guidelines and the provision of objective information about current environmental issues. Research extends to the impacts of droughts, beach erosion and the rise of sea level. Expertise is shared on the operation and management of farm ponds, the control of invasive plants and animals and the use of prescribed fire through public education workshops or private consultations. Clemson's Baruch Institute is involved in the reestablishment and management of longleaf pine habitat, endangered species habitat and forested wetlands.[85] Institute research continues to focus on the increasing demands on the coast's natural resources and on the impacts of changing land use on wildlife habitat, plant communities and the growth and vigor of the coastal forest.

The University of South Carolina has been conducting research and education programs at Hobcaw Barony since 1969. With support from the State of South Carolina, federal agencies and private contributors, USC's Belle W. Baruch Institute of Marine and Coastal Sciences has conducted hundreds of studies aimed at understanding how our waterways and marshes function and how they respond to natural and human-related changes in the environment. In any one year, between fifty to one hundred projects are conducted at USC's Baruch Marine Field Laboratory. On an average basis, over one hundred investigators, representing thirty or more institutions from around the world, might be working in the laboratory. USC professors, visiting scientists, technical staff and students seeking advanced degrees measure environmental conditions and conduct experiments throughout the year.

Results of studies in the five-thousand-acre salt marsh known as North Inlet Estuary help regulatory agencies set standards that strike a balance between socioeconomic needs and the long-term health of coastal resources. The North Inlet-Winyah Bay National Estuarine Research Reserve is one program that integrates research and education in support of coastal management and stewardship. Jointly funded by the National Oceanic and Atmospheric Administration and the University of South Carolina, NERRS conducts environmental monitoring, offers research experiences for students and the public and provides training programs for coastal decision makers. Information generated in studies at Hobcaw Barony is particularly valuable because it provides a basis for comparison with other estuaries that are affected by development, contamination and over-fishing. Cited as one of the best possible examples of an ocean-dominated marsh, the North Inlet Estuary is one of the most pristine and intensively studied coastal systems of its type anywhere in the world.[86]

In addition to the two institutes, the Baruch Foundation also offers a visiting scholars program and stipend available to the faculty of four-year colleges in South Carolina. By providing access to the resources of Hobcaw Barony, the foundation spurred the establishment and growth of the marine science departments at the College of Charleston, the University of South Carolina and Coastal Carolina University with the creation of majors and graduate degrees.

Belle's gift of Hobcaw Barony is held in perpetuity for the people of South Carolina, for the researchers and for the native plants and animals of the coast. This treasure, this bounty, this heritage she left for all is Belle's Legacy.

Early in her lifetime, Belle Baruch was aware of the pressures that caused Hobcaw to need protection. She bequeathed funds for preservation of the land for future generations.

With great foresight and love for Hobcaw Barony, Belle Baruch preserved the integrity of the property by protecting its natural resources and ensuring that, despite great change along the South Carolina coast, Hobcaw Barony would endure.

Chapter 1

1. Charles F. Kovacik and John J. Winberry, *South Carolina: A Geography* (Boulder, CO: Westview Press, 1987), 18–48.

2. Claude Neuffer and Irene Neuffer, *The Name Game* (Columbia, SC: Sandlapper Press, 1972), 3–4. Despite the fact that so many of South Carolina's rivers have Native American names, only a few of those names have been translated. See also *Correct Mispronunciations of Some South Carolina Names*, by Claude and Irene Neuffer (Columbia: University of South Carolina Press, 1983).

3. Dr. Chester DePratter, archaeologist with the University of South Carolina, reexamined shell piles in North Inlet in February 2005 to compare with heretofore unknown middens in the marsh behind Litchfield Beach. While most middens are oyster or mixed shell, middens at Litchfield are exclusively clam. Interview with the author, 2005.

4. Paul Hulton, *America 1585: The Complete Drawings of John White* (Chapel Hill: University of North Carolina Press, 1984), 134.

5. James L. Michie, *The Search for San Miguel de Gualdape* (Conway, SC: Waccamaw Center for Historical and Cultural Studies, University of South Carolina-Coastal Carolina College, Research Manuscript Series, 1991), 7–10.

6. Paul Quattlebaum, *Land Called Chicora* (Gainesville: University of Florida Press, 1956), 12.

7. Michie, *Search for San Miguel*, 33.

8. John Lawson, *A New Voyage to Carolina* (1709; reprint Chapel Hill: University of North Carolina Press), xv. The actual trip from Charleston to present-day Washington, D.C., was about 550 miles. Traveling in a dugout canoe and by foot, Lawson and five Englishmen, three Indian men, and one Indian wife followed the meandering creeks and rivers for fifty-nine days in winter weather. Lawson's trip journal details the group's daily activities.

9. Ibid., 218.

10. Jack Horan and Dan Huntley, "A Carolina Version of Lewis and Clark," *The State* [newspaper, Columbia, SC], September 2, 2001.

11. Suzanne Cameron Linder and Marta Leslie Thacker, *Historical Atlas of the Rice Plantations of Georgetown County and the Santee River* (Columbia: South Carolina Department of Archives and History, 2001), 11–12.

12. Chief Buster Hatcher of the Waccamaw Tribe, interview with the author, 2001. On February 18, 2005, the tribe received official state recognition from the South Carolina State Legislature's Committee for Minority Affairs.

Chapter 2

13. Linder and Thacker, *Rice Plantations*, 11–12.

14. Henry A.M. Smith, "The Baronies of South Carolina," *South Carolina Historical and Genealogical Magazine* 14.2 (1913): 61–80.

15. Rhett Johnson of the Longleaf Alliance, interview with the author, Hasty Point Plantation, Pee Dee River, Georgetown County, SC, July 2005. Lamenting the loss of the hardy native tree, Johnson works with landowners on a major initiative to regenerate longleaf pine in the southeastern United States.

16. Linder and Thacker, *Rice Plantations*, 13.

17. Lee G. Brockington. "The King's Highway: Yesteryear's Interstate," *Tidelands Magazine* [Georgetown, SC], Spring 2004: 14, 46.

Chapter 3

18. Ronald E. Bridwell, *That We Should Have a Port: A History of the Port of Georgetown, South Carolina, 1732-1865* (Georgetown, SC: The Georgetown Times, 1991), 9–12.

19. Linder and Thacker, *Rice Plantations*, 8.

20. Ibid., 14.

21. Ibid., 19.

22. Elizabeth Allston Pringle, *Chronicles of Chicora Wood* (1922; Spartanburg, SC: The Reprint Company and the Georgetown County Historical Society, 1999), 74–78.

23. Linder and Thacker, *Rice Plantations*, 31.

24. Arney Childs, ed., *Rice Planter and Sportsman: Recollections of J. Motte Alston, 1821-1909* (1948; reprint Columbia: University of South Carolina Press, 1999), 11.

25. Linder and Thacker, *Rice Plantations*, 36–37.

26. Richard Côté, *Mary's World: Love, War and Family Ties in Nineteenth-century Charleston* (Mt. Pleasant, SC: Corinthian Books, 2001).

27. Linder and Thacker, *Rice Plantations*, 48.

28. Charles Joyner, *Down by the Riverside: A South Carolina Slave Community* (Chicago: University of Illinois Press, 1984), 14.

29. Daniel C. Littlefield, *Rice and Slaves* (Baton Rouge: Louisiana State University Press, 1981), 100.

30. Ibid., 113.

Chapter 4

31. Linder and Thacker, *Rice Plantations*, 32.

32. Ronald E. Bridwell, *The Gem of the Atlantic Seaboard: Part II of A History of the Port of Georgetown, South Carolina, 1861–1988.* (Georgetown, SC: The Georgetown Times, 1991), 6.

33. Alberta L. Quattlebaum, *Georgetown Rice Plantations* (1955; Spartanburg, SC: The Reprint Company and Georgetown County Historical Society, 1993), 35.

34. Bridwell, *Gem of the Atlantic Seaboard*, 6.

35. Ibid., 23.

36. Linder and Thacker, *Rice Plantations*, 8. Tombstone inscription reads: Robert James Donaldson, born Armagh, Ireland [*sic*], October 20, 1836; died Georgetown, SC, November 21, 1894. Donaldson Family Cemetery, Hobcaw Barony, Georgetown, South Carolina.

37. Clipping from *The Georgetown Times* (November 22, 1902). "On the Monday night last, the threshing mill of Messrs. Donaldson Bros. was destroyed by fire. Besides the machinery, it contained about $1,500 worth of personal property. The fire originated from a hot journal and smoldered until midnight."

38. Bernard M. Baruch, *My Own Story* (1957; New York: Pocket Books, Inc., 1958), 242–43.

39. Lee G. Brockington, "The Caines Brothers: Legendary Decoy Carvers," *Tidelands Magazine* [Georgetown, SC], Spring 2005: 14–15, 42.

40. Baruch, *My Own Story*, 240.

Chapter 5

41. Baruch, *My Own Story*, 3. While Simon's parents put forth this genealogy, Bernard states, "On this claim Father himself was silent."

42. Margaret Coit, *Mr. Baruch* (1957; Washington, D.C.: Beard Books, 2000), 4–5. Mannes Baum gave Simon his Confederate uniform and a sword.

43. Patricia Spain Ward, *Simon Baruch: Rebel in the Ranks of Medicine* (Tuscaloosa: University of Alabama Press, 1994). Dr. Baruch set up a field hospital at the Black Horse Tavern near Gettysburg, where he treated Confederate and Union soldiers. In later years Bernard accompanied his father on an emotional visit to the site.

44. Theodore Rosengarten and Dale Rosengarten. *A Portion of the People: Three Hundred Years of Southern Jewish Life.* (Columbia: University of South Carolina Press, 2002), 11.

45. James Grant, *Bernard Baruch: The Adventures of a Wall Street Legend* (New York: Simon and Schuster, 1983), 23.

46. Baruch, *My Own Story*, 89–90.

47. Ibid., 94–95.

48. Letter in the Belle W. Baruch Foundation Archives from Annie Griffen Baruch to Belle W. Baruch, dated August 12, 1901. A postcard, dated February 10, 1907, reassures the children that they will soon be together and states, "Yes, I am bringing the chocolates and a stuffed bear as big as your sister."

49. Lois Massey (1901–1990) in separate interviews with the author Rhett Talbert and Mary Miller between 1982 and 1988. Lois's mother, Sarah P. Massey, was the sister of Baruch's head superintendent Jim Powell. Powell recommended his brother-in-law, Samuel T. Massey, as a mechanic for water and wiring needs. Lois came to Hobcaw with her family in 1916 and worked for the Baruch family for twenty-eight years.

50. Hobcaw Barony Guest Books; Bernard M. Baruch Papers; Seeley G. Mudd Manuscript Library, New Haven, CT. In addition, the invitation list for "Buffet Luncheon Hobcaw, January 1, 1938," showed over one hundred people invited to the luncheon from a three-county area, including about twenty Northern owners of local plantations, the mayors of Charleston and Georgetown, a nationally known horse trainer, a local sheriff, Jewish cousins, a Catholic playwright and several plantation managers. Notables included the Guggenheims, the DuPonts, the Pulitzers, the Rathbournes, the

Yawkeys, the Luces and Max Hirsch.

51. Coit, *Mr. Baruch*, 329.

52. Baruch, *My Own Story*, 258–60.

53. Hercules Shubrick, interview with the author, May 23, 2003. Hercules was the grandson of George Shubrick Sr. and son of Plucky Shubrick of Bellefield Plantation. The Shubricks attended church in Friendfield Village, and the children attended school in Strawberry Village. Hercules died shortly after this last interview, which was part of a family reunion on the plantation.

54. Isoline Beatty Lucas, interview with the author, April 25, 1985. Isoline was the daughter of Bernard Baruch's first boat captain in charge of the crafts at Hobcaw Barony. Joseph Francis Lucas, one of only a few licensed boat captains in Georgetown, worked at Hobcaw from 1905 to 1919. He maintained the yacht *Happy Days* and later boats were *Eagle Point*, *Skylark* and *Sea Dog*.

55. Francena McCants, interview with the author, May 1985. Francena was a teenager from Kingstree, South Carolina, when she first stayed with and babysat for the McClary family (formerly of Kingstree) in Friendfield Village. She married Charlie McCants Jr., of Strawberry Village, and they raised a family in Friendfield. Expecting a child when FDR visited in 1944, Francena was asked by the president to name her baby for him. Franklin McCants was born soon after. Despite hard work and long hours serving Mr. Baruch at Hobcaw House, and Belle and later Miss Severin at Bellefield, Francena reflects fondly on her bosses. One black employee said, "Thank you, God, for Mr. Baruch's pocketbook," with each evening prayer.

56. Robert McClary, interview with the author, August 12, 2004. Bob has published his memoirs after many visits to his boyhood home at Hobcaw. Raised in Friendfield and Barnyard Villages, Bob moved his mother and siblings to Detroit in 1952. Maudess McClary served as a cook's helper at Hobcaw House between 1937 and 1952 and visited the plantation in 2004 as part of a McClary family reunion.

57. Baruch, *My Own Story*, 252.

58. James L. Bessinger, Prince Jenkins, Moses Jenkins and Glenn Wilson, in conversations with the author. It is impossible to know and record every employee of the Baruchs, but large numbers of people were in the family's employ until the time of World War II. Black and white employees began to move off the plantation, but two descendants of slaves continued to work at Bellefield Plantation until the mid 1990s.

59. Boyd Marlow, interview with the author, June 24, 1986. Boyd Marlow moved to Hobcaw in 1923 to live with his relatives, the Vereens, when his mother died. He attended a school the Baruchs built about 1925 for the children of white employees. He remembers young, unmarried teachers, Miss Snow, Miss Janie Bell Royall and Miss Dottie Watts (who later married Captain Buxton). The one-room schoolhouse was abandoned after 1935 when the bridges to Georgetown were erected. The building was moved to Friendfield Village and served as a doctor's office or dispensary.

60. Minnie Kennedy, interview with the author, August 3, 2004. Born at Hobcaw to William and Daisy Kennedy, Minnie attended Strawberry School, then later public schools in Georgetown and entered South Carolina State College in 1935. Baruch had offered to underwrite the college education of any employee's child. By her senior year, Minnie's parents were managing to pay her tuition, but only by making extraordinary sacrifices. Minnie gathered receipts and records and sent them to Baruch's New York office with the "demand" that he keep his word. Baruch wrote Mr. Kennedy a check for the full amount but added, "However, your daughter is very rude."

61. Lucille Vereen DeLavigne, interview with the author, late 1980s. A daughter of Joe Vereen, superintendent of the woods, Lucille loved riding, bird hunting and climbing trees. She once had to shoot a rattlesnake with her shotgun. After graduating from a local business school, Lucille went to Washington to work for General Hugh S. Johnson, head of the National Recovery Administration.

62. Baruch, *My Own Story*, 261.

Chapter 6

63. Jordan A. Schwarz, *The Speculator: Bernard M. Baruch in Washington* (Chapel Hill: University of North Carolina Press, 1981), 252.

64. Lois Massey, interview for the videotape *Belle's Legacy*, Belle W. Baruch Foundation, 1981.

65. Baruch, *My Own Story*, 246–47.

66. Olive Buxton Mancill in conversation with Pratt Gasque of Murrells Inlet, the author of *Rum Gully Tales from Tuck 'Em Inn: Stories of Murrells Inlet and the Waccamaw Country* (Orangeburg, SC: Sandlapper Press, 1990). Olive was the only child of Captain Howard Buxton.

67. "A View of Our Past, 75 Years Ago," *The Georgetown Times* [South Carolina], August 2005: 2.

68. Celia Sandys, granddaughter of Sir Winston Churchill, in a lecture at Hobcaw House, January 2003. She is the daughter of Diana Churchill, who accompanied Churchill on his visit to Hobcaw in January of 1932. Celia has plans to film scenes at Hobcaw for a documentary on her grandfather's travels to America.

69. Mary E. Miller, interview with Lois Massey. *Alternatives Magazine* [Myrtle Beach, South Carolina], March 1988.

70. Genevieve "Sister" Peterkin, in a conversation with the author, August 2, 2004.

71. "FDR's Visit to 'Hobcaw,' Mr. Bernard Baruch's Barony Near Georgetown: April-May, 1944 [film footage]," Hyde Park, NY: Franklin D. Roosevelt Presidential Library.

72. Neal Cox, *Neal Cox of Arcadia Plantation* (Georgetown, SC: privately printed, 2003), 119–22. Mr. Cox was the superintendent for Dr. Isaac Emerson and his grandson George Vanderbilt on Arcadia between 1929 and 1999. In conversations with the author, April 1995, Cox added, "The woods were all eyes as we fished." Between the Secret Service and the Arcadia staff, many people saw the president reel in fish after fish that day.

73. Schwarz, *The Speculator*.

Chapter 7

74. Mary E. Miller, "Baroness of Hobcaw" (unpublished manuscript, 2005). Belle's first word for her father was Papa, but her nickname for him, Chick, came in her adulthood.

75. Ambrose Gonzales, *Black Border: Gullah Stories of the Carolina Coast* (1922; reprint Gretna, LA: Pelican Press, 1998), 183.

76. Coit, *Mr. Baruch*, 328.

77. "New York Girl of 13 Kills Deer," *The New York Herald*, December 30, 1911.

78. Many Georgetonians remember being buzzed by Belle's plane. One resident, who prefers to remain anonymous, remembered nearly capsizing in the rice fields of Hobcaw Barony as Belle flew low over his boat. When asked if that experience cured him of poaching, he smiled and with a turn of his head said, "It sure cured me of poaching on Belle Baruch's plantation!"

79. Most of Belle's riding awards were won in France, and 171 of the 300 plaques she received still

hang from the eaves of her stable at Bellefield.

80. Rhett Talbert, interview with Ella Severin for the film *Belle's Legacy*, 1981. The twenty-minute video is shown by request at the Hobcaw Barony Visitor Center.

81. Charlotte Taylor Altman, interview by University of South Carolina students for Tales of the Tidelands, an interdisciplinary research course, Fall 2004.

82. Lucille DeLavigne, interview with the author, late 1980s.

83. Miller, "Baroness of Hobcaw."

Chapter 9

84. Ella Severin, interview with the author, April 1990. Miss Severin was a life trustee and served in a unique position of stewardship from Belle's death in 1964 until her own death in 2000.

85. George Askew, PhD, Director of the Belle W. Baruch Institute of Coastal Ecology and Forest Science at Hobcaw Barony.

86. Dennis Allen, PhD, Director of the Belle W. Baruch Institute of Marine and Coastal Sciences Field Laboratory at Hobcaw Barony.

Bibliography

Babcock, Havilah. *My Health Is Better in November.* Columbia: University of South Carolina Press, 1947.

Baldwin, William P., and N. Jane Iseley. *Lowcountry Plantations Today.* Greensboro, NC: Legacy Publications, 2002.

Ballentine, Todd. *Tideland Treasure.* Hilton Head, SC: Deerfield Publishing, 1983.

Baruch, Bernard M. *My Own Story.* 1957. New York: Pocket Books, Inc., 1958.

Beach, Virginia Christian. *Medway.* Charleston, SC: Wyrick & Company, 1999.

Bellefield Guest Book. Records, December 24, 1937–July 1975. Georgetown, SC: Hobcaw Barony Archives.

Bridwell, Ronald E. *That We Should Have a Port: A History of the Port of Georgetown, South Carolina, 1732–1865.* Georgetown, SC: The Georgetown Times, 1982.

Bridwell, Ronald E. *The Gem of the Atlantic Seaboard: Part II of A History of the Port of Georgetown, South Carolina, 1861–1988.* Georgetown, SC: The Georgetown Times, 1991.

Brockington, Lee G. "The Caines Brothers: Legendary Decoy Carvers." *Tidelands Magazine* [Georgetown, South Carolina], Spring 2005.

———. "The Kings Highway: Yesteryear's Interstate." *Tidelands Magazine* [Georgetown, South Carolina], Spring 2004.

———. "Men of Vision: Prussian Immigrants Heiman Kaminski, Simon Baruch Left a Mark on the Face, Future of Georgetown." *The Georgetown Times* [South Carolina], September 17, 2003.

———. "A One Room Schoolhouse on the Waccamaw Neck." *Lowcountry Companion* [Pawleys Island, South Carolina], Spring 2002.

Childs, Arney R., ed. *Rice Planter and Sportsman: Recollections of J. Motte Alston, 1821–1909.* 1948; reprint Columbia: University of South Carolina Press, 1999.

Coit, Margaret L. *Mr. Baruch.* 1957; reprint Washington, D.C.: Beard Books, 2000.

Côté, Richard. *Mary's World: Love, War and Family in Nineteenth-century Charleston.* Mt. Pleasant, SC: Corinthian Books, 2001.

———. *Theodosia Burr Alston: Portrait of a Prodigy.* 2002; reprint Columbia: University of South Carolina Press, 2003.

Bibliography

Cox, Neal. *Neal Cox of Arcadia Plantation: Memories of a Renaissance Man*. Georgetown, SC: Privately printed, 2003.

Devereux, Anthony Q. *The Life and Times of Robert F. W. Allston*. Georgetown, SC: Waccamaw Press, Inc., 1976.

Edgar, Walter. *South Carolina, A History*. Columbia: University of South Carolina Press, 1998.

Elliott, William. *Carolina Sports by Land and Water: Including Incidents of Devil-Fishing, Wildcat, Deer & Bear Hunting, Etc.* 1846; reprint with an introduction by Theodore Rosengarten. Columbia: University of South Carolina Press, 1994.

"FDR's Visit to 'Hobcaw,' Mr. Bernard Baruch's Barony Near Georgetown: April–May, 1944 [film footage]." Hyde Park, NY: Franklin D. Roosevelt Presidential Library.

Genovese, Eugene D. *Roll Jordan, Roll: The World the Slaves Made*. New York: Vintage Books, 1976.

Georgetown County Library. *A View of Our Past: The Morgan Photographic Collection Depicting Georgetown, South Carolina c. 1890–1914*. Georgetown, SC: Georgetown County Library System, 2002.

Gonzales, Ambrose E. *The Black Border: Gullah Stories of the Carolina Coast*. 1922; reprint Gretna, LA: Pelican Press, 1998.

Grant, James. *Bernard Baruch: The Adventures of a Wall Street Legend*. New York: Simon and Schuster, 1983.

Heyward, Duncan Clinch. *Seed from Madagascar*. Spartanburg, SC: The Reprint Company, 1983.

Hobcaw Barony Guest Books. Bernard M. Baruch Papers, Seeley G. Mudd Manuscript Library, New Haven, CT.

Horan, Jack, and Dan Huntley. "A Carolina Version of Lewis and Clark," *The State* [newspaper, Columbia, South Carolina], September 2, 2001.

Hulton, Paul. *America 1585: The Complete Drawings of John White*. Chapel Hill: University of North Carolina Press, 1984.

Hurmence, Belinda, ed. *Before Freedom, When I Can Just Remember: Twenty-seven Oral Histories of Former South Carolina Slaves*. Winston-Salem, NC: John F. Blair, Publisher, 1989.

Joyner, Charles. *Down by the Riverside: A South Carolina Slave Community*. Chicago: University of Illinois Press, 1984.

Kovacik, Charles F., and John J. Winberry. *South Carolina: A Geography*. Boulder, CO: Westview Press, 1987.

Lawson, John. *A New Voyage to Carolina*. 1709; reprint Chapel Hill: University of North Carolina Press, 1984.

Linder, Suzanne Cameron, and Marta Leslie Thacker. *Historical Atlas of the Rice Plantations of Georgetown County and the Santee River*. Columbia: South Carolina Department of Archives and History, 2001.

Littlefield, Daniel C. *Rice and Slaves*. Baton Rouge: Louisiana State University Press, 1981.

Lucas, Silas Emmett. *Mills' Atlas: Atlas of the State of South Carolina*. Easley, SC: Southern Historical Press, 1980.

Markham, Beryl. *West with the Night*. Boston: 1942; reprint Houghton Mifflin Co., 1983.

Marks, Stuart A. *Southern Hunting in Black and White Nature: History and Rituals in a Carolina Community*. Princeton: Princeton University Press, 1991.

McClary, Robert C. *Sandy Island, Cedar Swamp, Hobcaw and Beyond: My Story—My Life*. Detroit: Privately printed, 2003.

Michie, James L. *The Search for San Miguel de Gualdape*. Conway, SC: Waccamaw Center for Historical and Cultural Studies, University of South Carolina-Coastal Carolina College, Research Manuscript Series, 1991.

Miles, Suzannah Smith. *The Sewee: The Island People of the Carolina Coast*. Charleston, SC: privately printed, 2001.

Miller, Mary E. "Baroness of Hobcaw." Unpublished manuscript, 2005.

———. Interview with Lois Massey. *Alternatives Magazine* [Myrtle Beach, South Carolina], March 1988.

Milling, Chapman J. *Red Carolinians*. Columbia: University of South Carolina Press, 1969.

Neuffer, Claude, and Irene Neuffer. *The Name Game*. Columbia, SC: Sandlapper Press, 1972.

"New York Girl of 13 Kills Deer." *The New York Herald*, December 30, 1911.

Peterkin, Genevieve. *Heaven Is a Beautiful Place*. Columbia: University of South Carolina Press, 2000.

Porcher, Richard D. *Wildflowers of the Carolina Lowcountry and Lower Pee Dee*. Columbia, SC: University of South Carolina Press, 1995.

Pringle, Elizabeth Allston. *Chronicles of Chicora Wood*. 1922. Spartanburg, SC: The Reprint Co. and the Georgetown County Historical Society, 1999.

Quattlebaum, Alberta Lachicotte. *Georgetown Rice Plantations*. 1955. Spartanburg, SC: The Reprint Company and the Georgetown County Historical Society, 1993.

Quattlebaum, Paul. *Land Called Chicora*. Gainesville: University of Florida Press, 1956.

Rogers, George C., Jr. *The History of Georgetown County, South Carolina*. Columbia: University of South Carolina Press, 1970.

Rosengarten, Theodore, and Dale Rosengarten. *A Portion of the People: Three Hundred Years of Southern Jewish Life*. Columbia: University of South Carolina Press, 2002.

Schwarz, Jordan A. *The Speculator: Bernard M. Baruch in Washington*. Chapel Hill: University of North Carolina Press, 1981.

Smith, Henry A.M. "The Baronies of South Carolina." *South Carolina Historical and Genealogical Magazine* 14.2 (1913): 61–80.

"A View of Our Past, 75 Years Ago," *The Georgetown Times* [South Carolina], August 2005.

Ward, Patricia Spain. *Simon Baruch: Rebel in the Ranks of Medicine*. Tuscaloosa: University of Alabama Press, 1994.

Weir, Robert M. *Colonial South Carolina, A History*. Columbia: University of South Carolina Press, 1997.

Wood, Peter H. *Black Majority*. New York: W.W. Norton & Co., 1974.

Index

About the Author

Photo by Charles Slate.

Lee Gordon Brockington is the senior interpreter for the Belle W. Baruch Foundation at Hobcaw Barony. A graduate of Columbia College and participant in the Seminar for Historical Administration at Colonial Williamsburg, she is a former curator of education for the Historic Columbia Foundation. Her research has appeared in newspapers and magazines and she served as editor for the book *Pawleys Island*, a collection of oral history interviews published in 2003.